MW00988686

A i 3 ANTONIO
DELLA MIA VITA!

MIO PADRE
ANTONIO D'AMICO
MIO NIPOTE

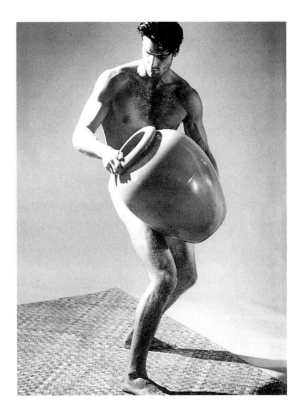

Men
Without Ties

Barry Hannah
Richard Martin
Bob Wilson
Gianni Versace

A TINY FOLIO ™
Abbeville Press Publishers
New York London Paris

I intended to do a book about my work, about men's fashion, but as I was choosing drawings and photographs from the archives, I realized that for years I had been working on people that I had always seen as being free from constrictions. Now I believe that I've produced a book about style, about men of very marked individuality who have had and still have style, without realizing it.

GIANNI VERSACE

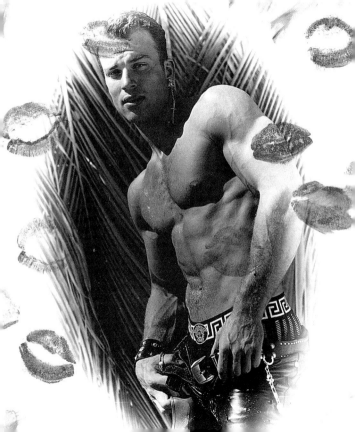

Gianni Versace's New Men

Richard Martin

> Man is a prisoner …
> – Socrates, *Dialogues of Plato*, Phaedo. 62

The freedom of man is an allegory and a figure of speech. Sovereignty, franchise, governance, and cultural autonomy establish the frame for a fabulous freedom, permitting men and women to act in accordance with their own fulfillment. Clothing abets this desire and is a recurrent agent of freedom. But clothing—and perhaps the polity and other social liberty—is seldom solely liberating and open. Men, as well as women, have long been the victims of fashion.

In the beginning the necktie expressed, first, cleanliness of an under-layer; second, the perimeter of the neck and collar; and, third, the expressive interpretation of a knotting, tethering practice; now the necktie has become a convention of withered utility. At its inception in the seventeenth century, in the era of the Thirty Years War, the cravat or tie was a mark of military conformity and propriety, even as it returned to Paris in commemoration of the French victory at Steinkerque. In the nineteenth century the tie became a bourgeois sign and evolving

emblem of the man of business. Gaining more commercial and conventional orthodoxy with every businessman represented in the decades of enterprise and individualism, the tie emerges into the twentieth century as a trim and taut sign of the business establishment. The tie is the simplest indication of the Industrial Age's commercial etiquette, with management following executives, bosses imitating managers, clerks cloning bosses. The convention is especially compelling because, like any vestigial sign, the tie cannot be questioned because its reason and its cause have become so thoroughly lost and sacredly mysterious. Freud's ahistorical interpretation of the necktie as vector from neck to penis attributed to the already bourgeois necktie an animation that was, by Freud's time, ill-deserved. Invoking reason, the persnickety historian can lament the continued presence in the contemporary wardrobe of an item that has become dissociated from its original meaning and purpose. But the historian's annoying niggling will not loosen the Gordian knot of any neckwear. And much of what we wear today has lost its function and sacrificed its memory to a kind of rote, unquestioning dressing. If we were to start interrogating our habits in dress, we would all become clothing reformers like those stony utopians of the turn of the century. Fortunately, Gianni Versace has taken the initiative and become our era's vehement and unrelenting

8

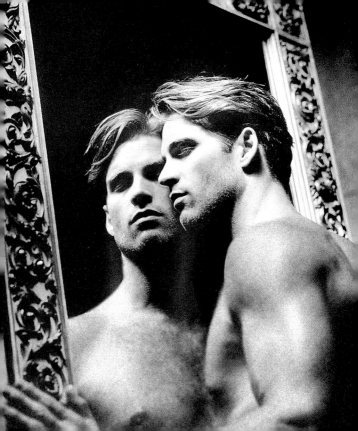

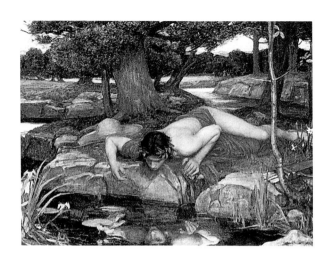

It's too bad to not love yourself a little bit ...

GIANNI VERSACE

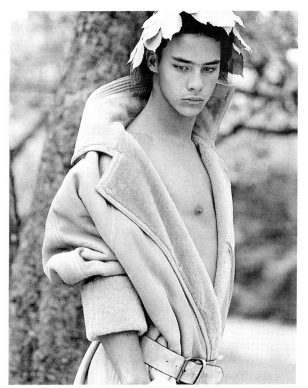

11

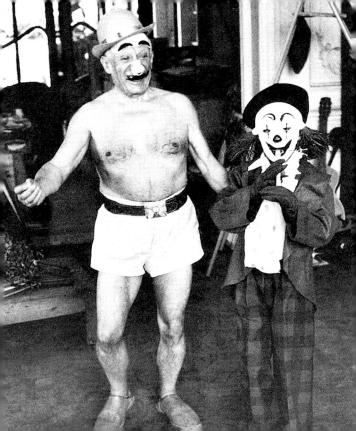

reformer, demanding change in menswear that begins by shedding the tie and goes from that seemingly simple act to a whole new conception of man in his attire and world.

Of course, if we were only talking about the tie, its cause would seem infinitely small and inconsequential. The tie—and its elimination—is not just a matter of a men's style shift, but of a completely different way of identifying men, displacing "man," the gender and the category, from all the long-standing functions of bourgeois life and attire. To see the man without a tie in the 1990s is, in fact, to reconceptualize man. Versace's originality is not fashion nuancing, but deep cultural and personal reidentification of and for men.

Versace makes us be and see a new man, specifically of his and our own sartorial making, but even more generally a man of our era, a man who stands away from the occupationally-determined past, bereft of tie, unfettered by the bourgeois values that are associated with the tie. Who is this new man who is so unabashedly designed, admired, and propagated by Versace?

His characteristics are several and they are culturally important, interpreting our time and commanding a vision for men in the future. In this sense, Versace is the utopian futurist we

have always known him to be, and his Samurai-knight Luke Skywalker leathers and breastplates of the early 1980s have brought us logically to his thorough reconsideration of men's roles. This new man is of the future and markedly free. Versace's tour-de-force knowledge of cultural and menswear history does not deny his new man a memory and even an evocative yearning for the past, but Versace's man is not constrained by bourgeois role or history. This is truly a story of freedom and of individualism.

While the necktie reinforces the symmetry of the body, it bears little relationship to the silhouette. Fashion silhouettes have customarily been identified with women, but men's shapes are important as well. Versace is a Cubist and Futurist of our time, insisting upon the male silhouette as broad-shouldered, narrow-waisted, and muscular-legged. Long before the gym-built physiques of the late 1980s and 1990s, Versace was specifying the male silhouette in an undeniable indication of the preferred body. Like any body preferred by design, it can be achieved not merely by those who possess its form naturally or by muscle-building construction, but even by those who accept its design principles. The necktie is a delusion, and superfluous to the silhouette that Versace prefers: the very presence of the tie would diminish the extreme triangulation of the

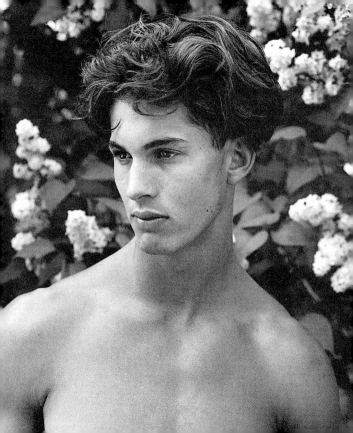

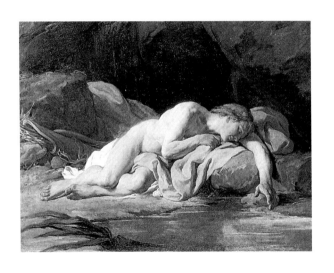

16

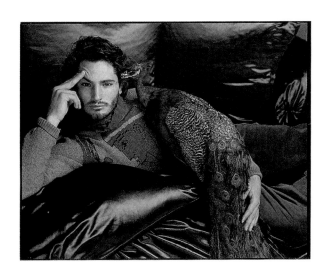

*A tuxedo alone doesn't make you elegant,
while even a pair of underpants can be worn
with style.*

GIANNI VERSACE

torso; the tie which apparently brings the torso into connection with the waist would mitigate Versace's joy in the narrowing of the waist and the conception of the male body as an aggregate of perfect shapes.

Further, in eliminating the necktie, Versace develops and explores the options of the exposed neck and torso. The reason why traditional menswear seems so immediately awkward and geeky beside Versace's futurist ideals is that Versace has not only transformed the silhouette, but has removed the anxieties of the coverings: neck, collar, and tie. If you recall the sportswear of the 1930s and 1940s—as exemplified in the Golden Age of Hollywood movie star portraits— their allure was often in the broad spread of open-collared shirts that would emulate and visually extend the breadth of the shoulders. Like a woman's broad collar or even more like her variable décolletage, the opening up of the collar allows for a freedom we have traditionally associated with ease, comfort, sexual self-expression, and even with the highest expression of style. Versace is well aware of these glamorous 1930s and they are a heritage for his elegant men of today, not only in silhouette, but also in the return of pattern and flamboyant design to men's shirts. These movie stars—William Powell, Robert Montgomery, Robert Taylor, Tyrone Power, and, of course, Gary Cooper—

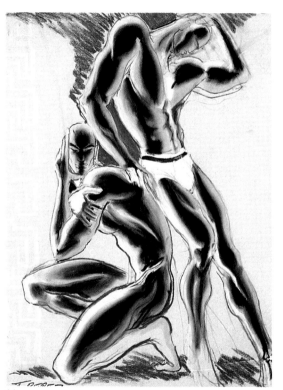

20

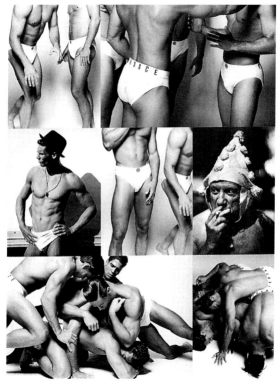

offer a debonair ideal of their era, relaxed in a repose that loosens the tie, wearing a sport jacket with bold shoulders, or even discarding the tie in favor of an open-collared sport shirt. From these ideal images comes an alternative to the "tied" bourgeois standard. Versace gives us the magic of these Hollywood idols, along with all their star quality and enduring glamour, in opening up the shirt collar and denying the convention of a tie.

Yet even these stars lived in a world of strict codes that required dressing for dinner and for occasions of business. In our time, a casual style prevails even for a great many business transactions; formality is ebbing away from our conduct of business and Versace is one of the first fashion designers to conceive of fashion for a new generation of men who conduct their affairs through personal expression, by advanced communications, and in a reality not virtual, but fundamentally different from the commerce of the past. Entertainment, fashion, arts, and leisure enterprises are now most often dominated by men who dress down and are often seen without tie and/or jacket. Henry Ford's strait-laced propriety in dark suit and tie is no longer the way of doing business, at least in significant business sectors in Italy and America. With the changing image of the executive as an entrepreneur of less formal sensibility—and

even of "Friday casual dressing" for all subordinates—business suits and ties are no longer *de rigueur*. Menswear has, for the most part, been gradually dressing down and, step by step, deconstructing its stiff tailoring.

Versace has been more decisive. He has chosen not to chip away at male stolidity. Versace is a prophet, making the deliberate choice not to dress down in stages, but to eradicate and reconstruct his new man entirely like a wonderful bionic creature that begins without every having had the premise of a tie or jacket.

Breaking the mold of the bourgeois man, Versace explores the possibility of the sensuous man. Knowing the taboo of masculine grace and vanity, Versace has confronted contemporary culture with an audacious, even insolent, narcissism of the male. Flaunting male grace with the elegance of a Renaissance prince in evocation of the era of individualism, Versace has chosen to present male beauty. It is not a silhouette derived from womenswear, nor the fabrics or colors associated with womens wear, that Versace seizes to push menswear to a self-aware expression of individualism. Versace projects a strong sense of masculine identity, imbued with myth, empowered by tradition, and made compelling by its absolute, unequivocal strength of

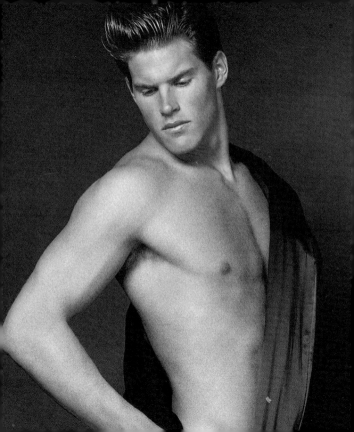

conviction. Versace does not compromise: the power is the declaration without any conditions, the attention given to stylistic concept. Superheroes in leather, spectrum, and prodigious physique at South Beach are not designed for the faint of spirit or the uncertain of body or self. Versace designs with determination, not with hesitation.

Arguably, all fashion is compelled by sex and power. Versace's brave men are perhaps no more expressive of sex and power than any other men of fashion, though sex in apparel for Versace can be overt, not just covert, not just straight but provocatively touched by bisexuality or homosexuality. The erotic sensuality of the open neckline is a key element in Versace's imagery. Uncovering the neck and chest risks vulnerability; it incorporates body and clothing more intimately than our convention of impersonal, unexpressive modern menswear. Collar and tie had long suppressed the male chest as an erogenous zone in the Western world, but Versace realizes that any degree of exposure of the chest defines the male body, especially in the male secondary sexual characteristic of chest hair. The man with a tie tells us nothing of the body within and this disaffiliation with the body of the man is society's loss. Puritanical reserve, association of body hair with the animalistic, and other inhibitions had repressed the chest, as on the beaches of the United

States (where men wore tank tops even until 1933-35) and in male movie star photos—chest hair airbrushed out—through the 1940s. Versace's deep V-shaped openness at center front often allows the chest to be seen and expressed; his vests even further expose and explore the male body. Exposure of the chest in circumstances of dress, whether modest or radical, is a significant gesture of change for men in the 1980s and 1990s. The cultural root of this baring of the male chest is our contemporary examination of gender and sexuality; an inevitable sign of equivalence to women's traditional décolletage, it is at the same time an anatomical sign of gender difference. Indeed, the sculpture of the male chest is, like that of the female chest, a personal idiosyncracy (to some degree a given, not a perfect social norm), even if altered in the case of women by bra shaping or even surgery, or in the case of men by gym-pumping and shaving. Versace has opened a new erogenous zone in men, but one that is brought to display and discourse only by the innovation of the designer. That is, the world of David Bartons and Arnold Schwarzeneggers is forever a fiction until a fashion designer makes their muscled and callipygian physicality an option of dress, one for such heroes, but which can also be approached by lesser mortals.

Versace has offered countless alternatives to the closed collar, including a 1980s soft and scooping boat-neck that

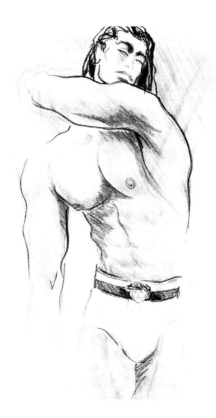

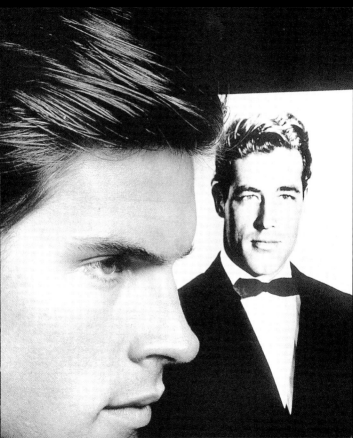

naturally falls below the clavicle, 1990s zipper fronts that borrow from womenswear in suggesting sartorial ease, and men shown with shirts wholly open, buttoned or tied only at the waist, partly buttoned with placket above turned under, or worn freely untucked and susceptible to breezes. These are all design options indicative of the wide choice and privilege granted to the Versace man to wear the clothing as he sees fit and feels comfortable. Versace defies decorum and prefers self-expression. In most cases, the same shirt or top is versatile and can be worn many ways, once the limitations of the tie and collar are dropped. The anthropologist and cultural historian know that our current curiosity about gender, and the desire to transform gender in this society, can only be accomplished in cultural spectatorship. Foremost among all designers of our time, Versace has used the abandonment of the tie to expose the torso and to recreate our view of the male body in a new way. Versace recently told Amy Spindler in the *New York Times* (June 30, 1994) of his menswear proportions, "I wanted them to have a swimmer's shape. Ten years ago, it was important to look like Woody Allen or Schwarzenegger. Now it's mixed." Mixing these men is Versace's invention. He creates heroes. But he creates them in an intelligent, cultural manner that serves any man of our time, whether gym-buffed or merely seeking a self-image beyond bourgeois convention.

New clothes can be a brilliant originality and a wonderful invention, and one can praise Versace for this. But to invent a new man, this wondrous, versatile, open, and free man without a tie is something more than ingenuity in the trivial realm of clothes. It is a concept of contemporary man in the tradition of futurism and the speculation about men's lives. Versace gives us the opportunity to break with bourgeois convention, long hardened and oppressive but wholly disingenuous in our time. Versace tells us forcefully that we are not slaves and have nothing to lose but our meaningless, anachronistic neckties. Male or female, we enjoy the gift of Versace's vision for our time and the future. But men in particular have a new image in Versace, a new idealism, a cultural emancipation. Versace creates a new man: no prisoner, but a concept of gender beauty, a figure of freedom.

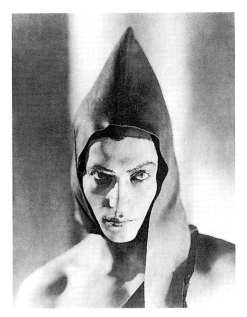

Style makes sense only if it is your own.

GIANNI VERSACE

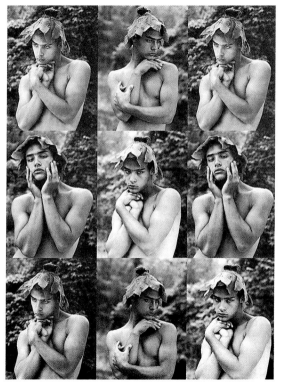

33

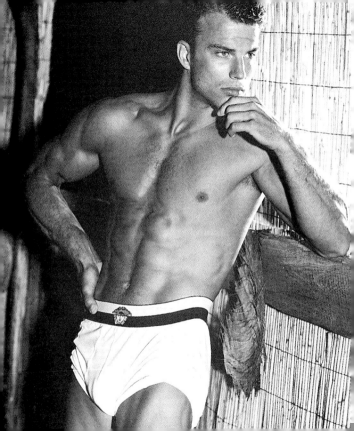

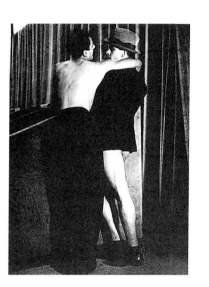

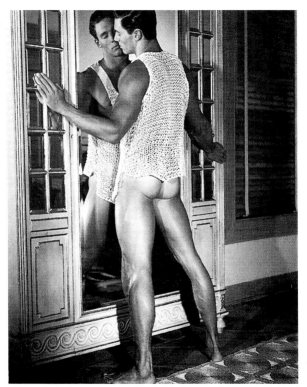

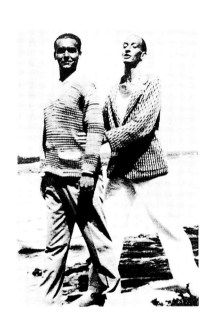

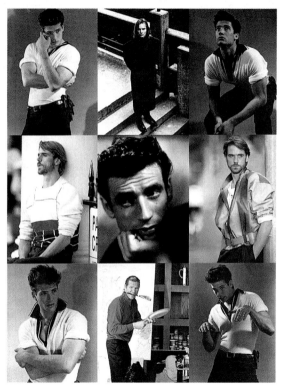

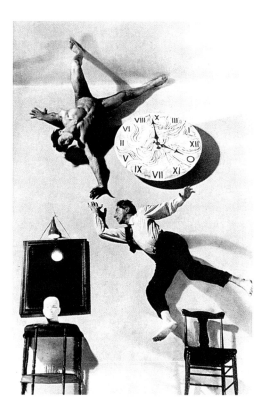

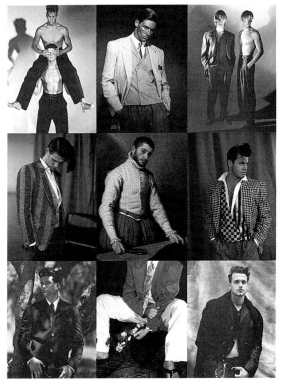

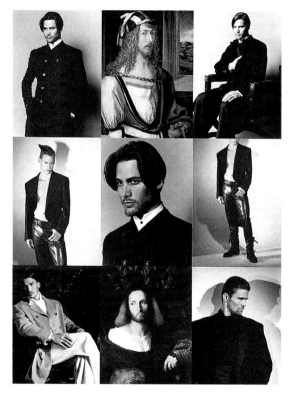

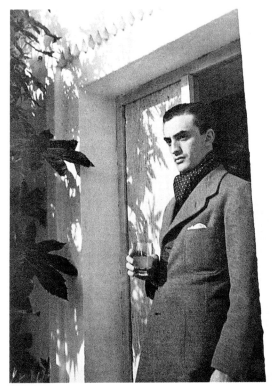

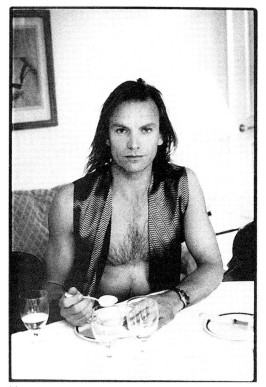

44

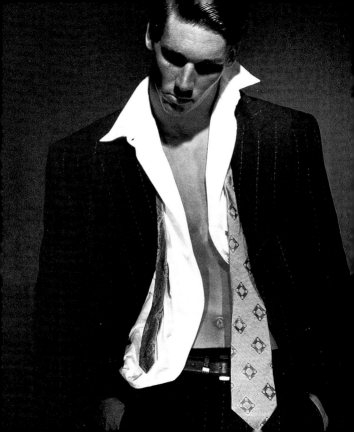

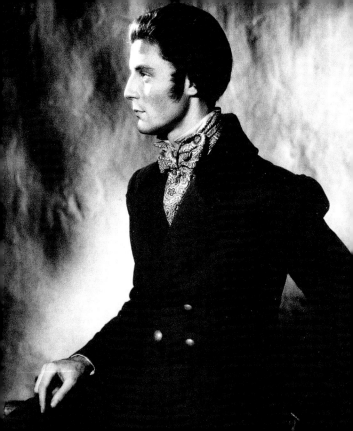

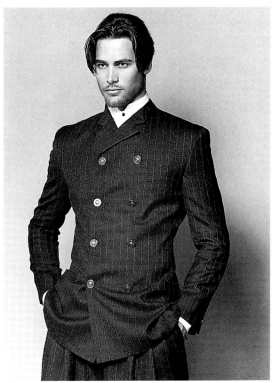

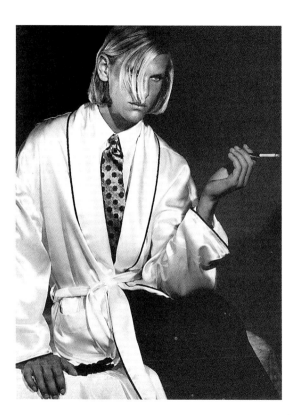

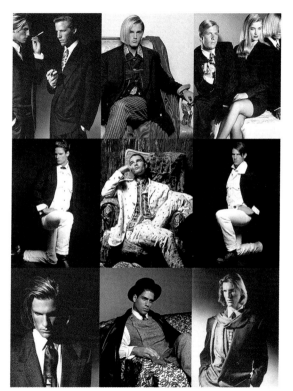

49

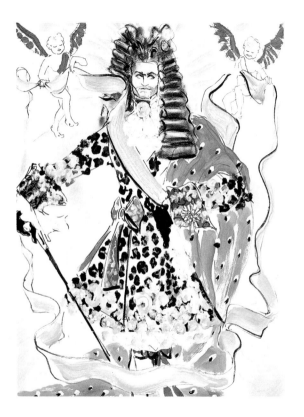

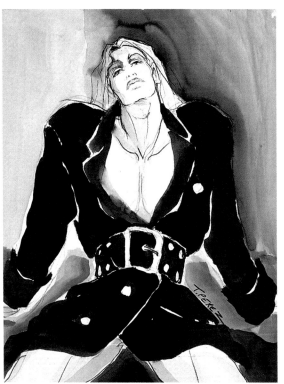

52

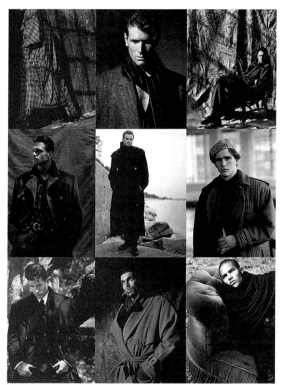

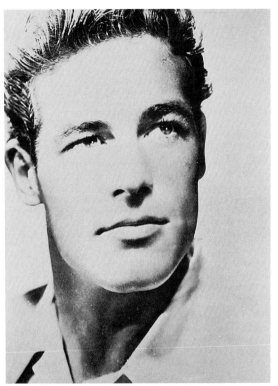

54

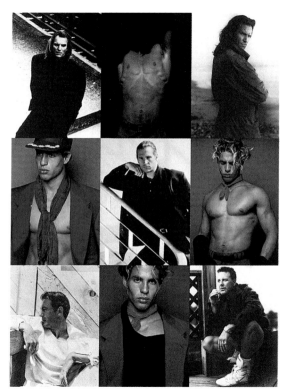

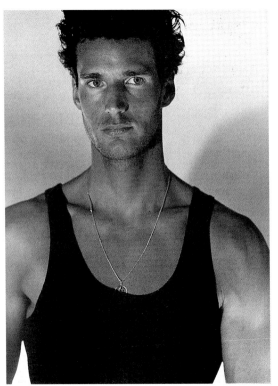

56

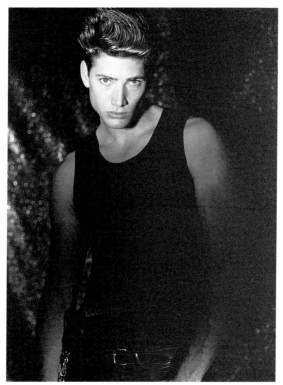

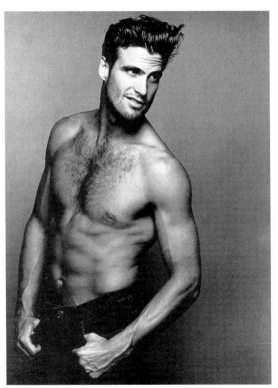

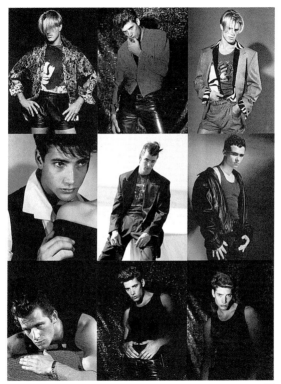

59

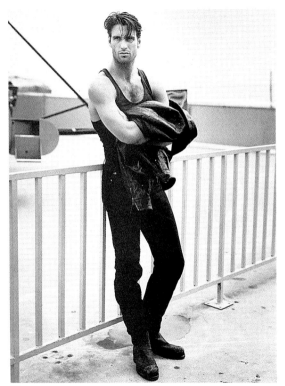

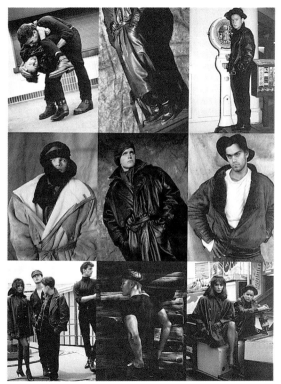

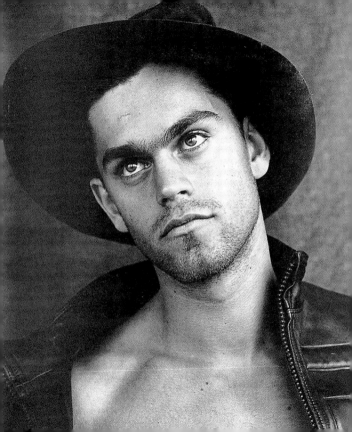

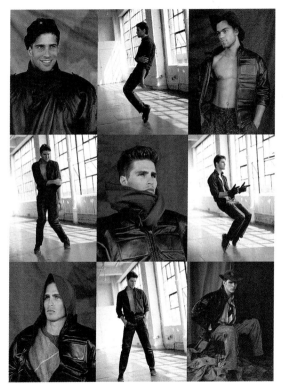

63

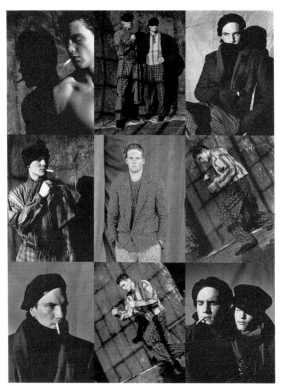

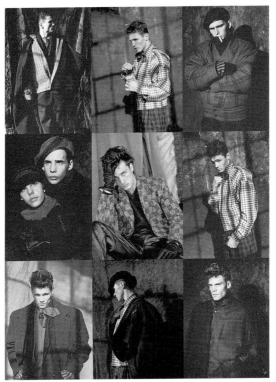

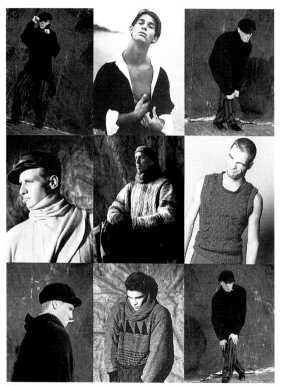

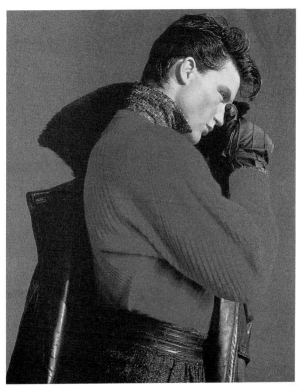

MY NAME IS MAN

A MON MON A MON

A

B
my name is bob

A

B
my nAme

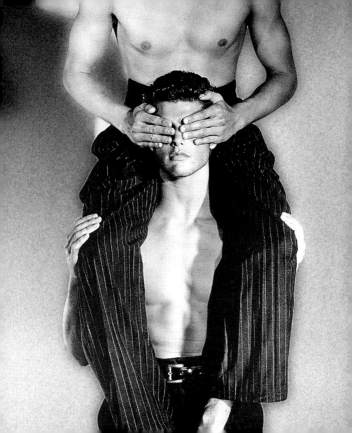

A Monster of a Grace

B for Dest wish

A

ABOUT TOYS ARE SO BEAUTIFUL
ABOUT PLAYING
ABOUT PLAYING WITH TOYS
A TOY

SO NICE INTO IT
SO NICE INTO
SO NICE

SO NICE INTO IT
OF THIS MINUTE YOU
ARE SO SWEET

LIKE A TOY INTO IT

YOU ARE SO FINE

TO PLAY WITH IT

IT IN MY HAND

B Because A B

Because I Love

You
You ARE SO KIND Fuck Love

You play A Play Love Lo

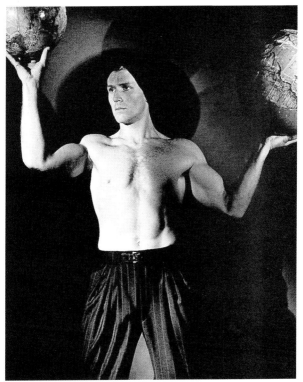

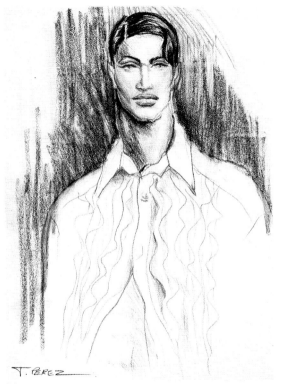

T. PEREZ

74

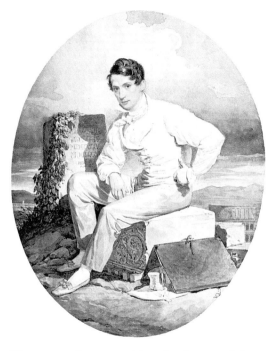

Ties ... make everything look out of date.

GIANNI VERSACE

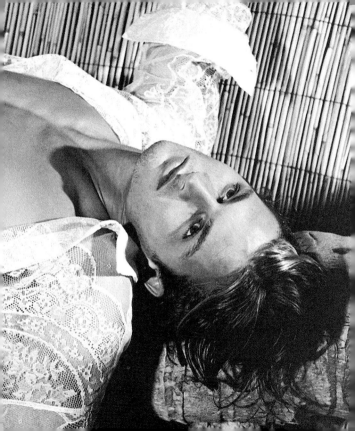

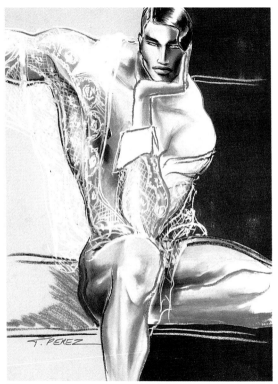

T. PEREZ

78

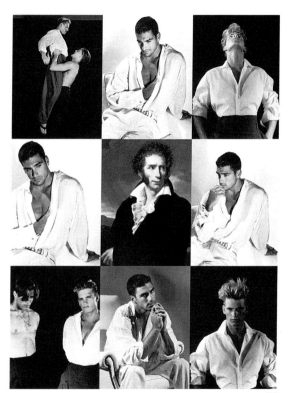

79

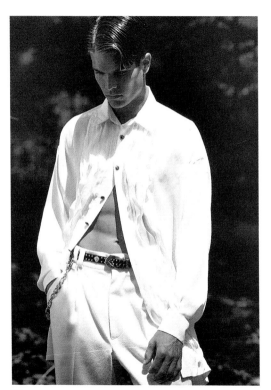

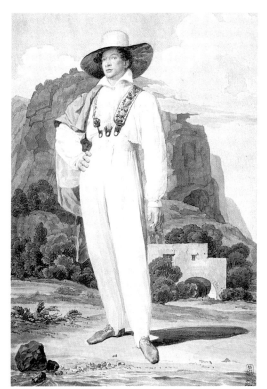

81

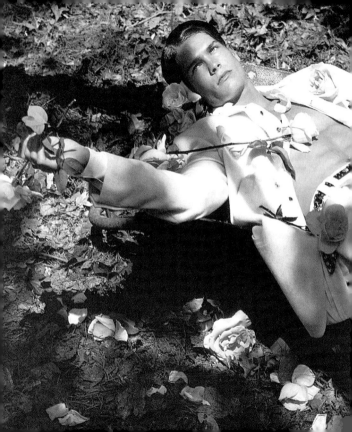

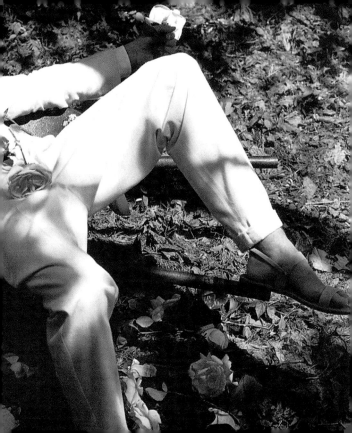

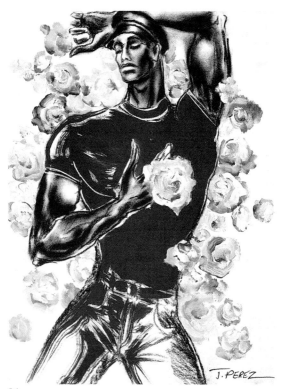

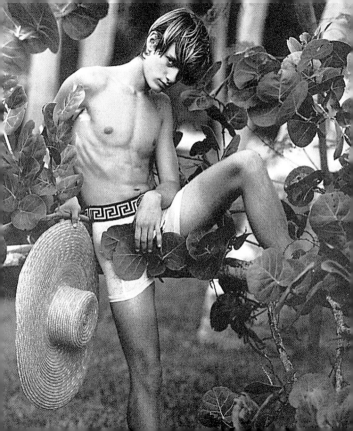

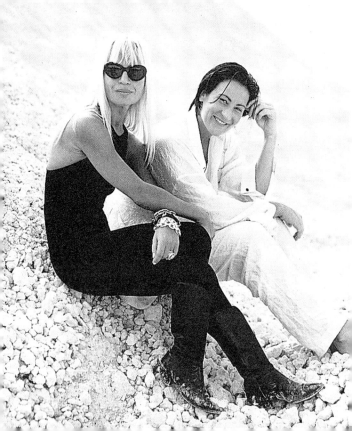

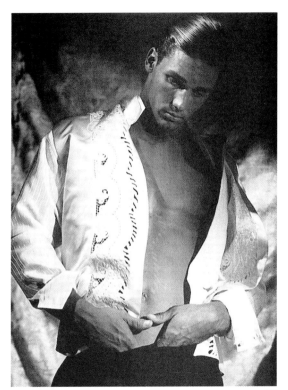

87

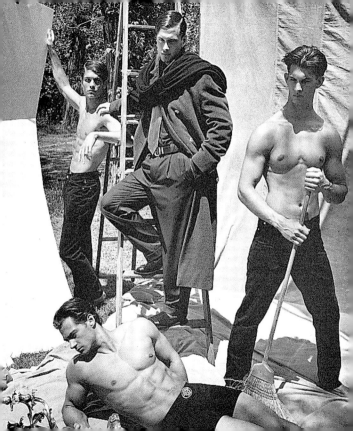

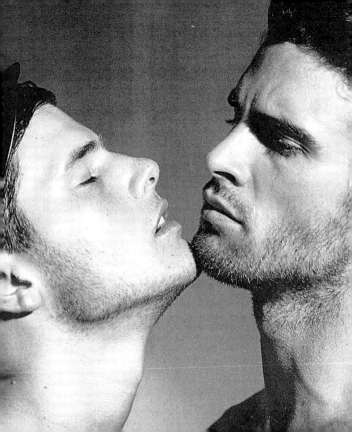

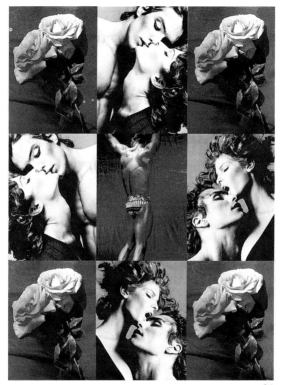

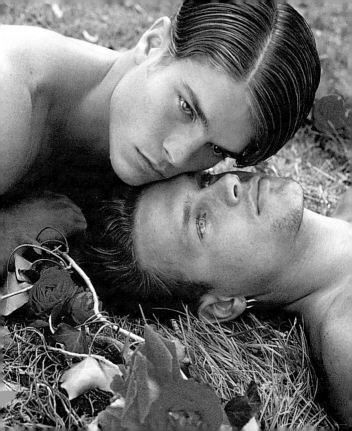

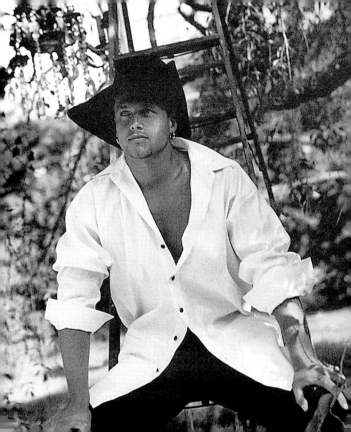

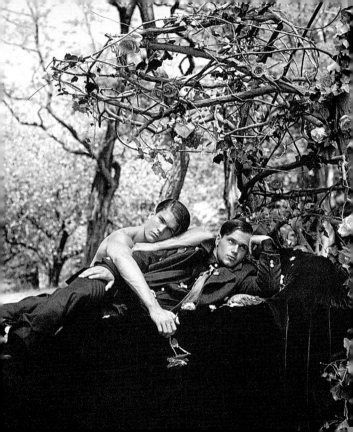

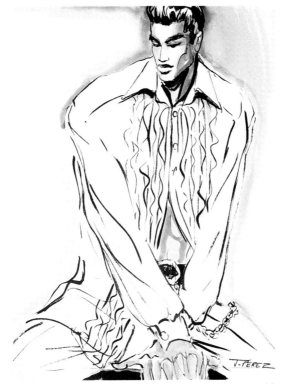

T. PEREZ

95

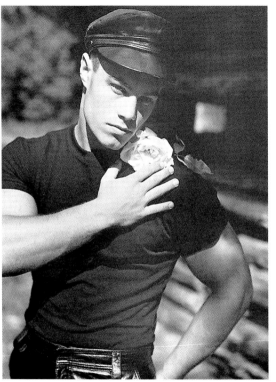

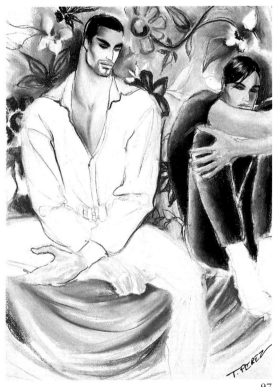

T. PEREZ

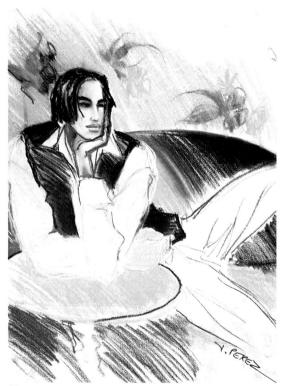

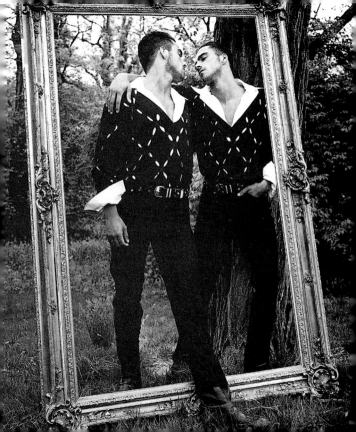

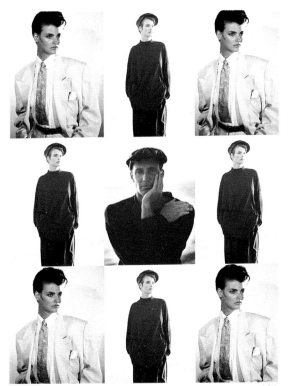

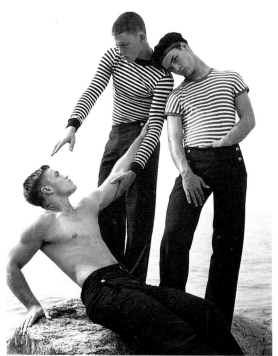

103

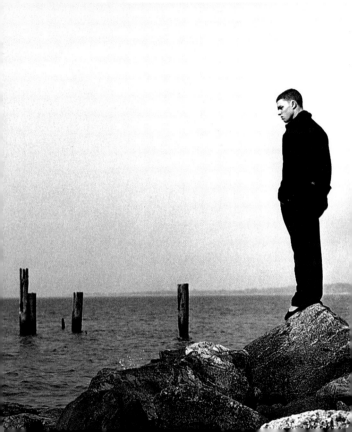

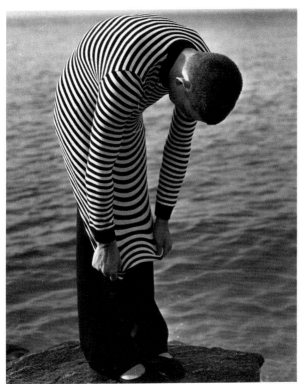

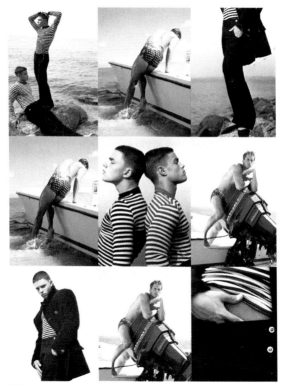

106

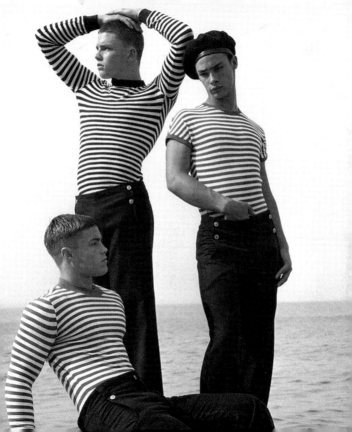

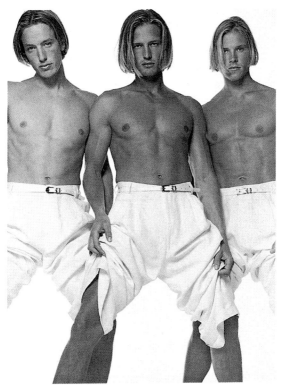

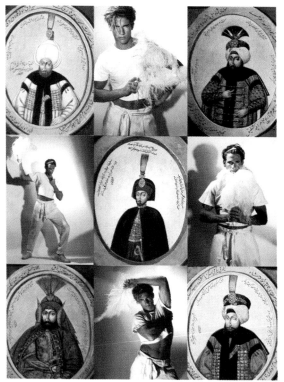

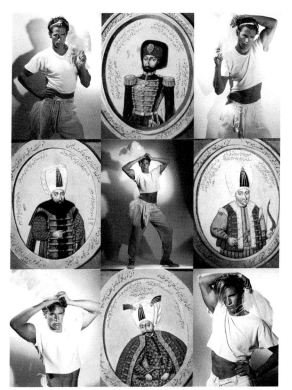

I don't understand those who are professionally cultured. I like pop culture, the culture that doesn't need to show off. Real culture is one with life; it doesn't need to be camouflaged, and it has a lightness that remains unchanged even when at its most profound.

GIANNI VERSACE

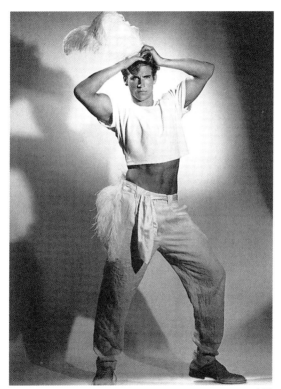

113

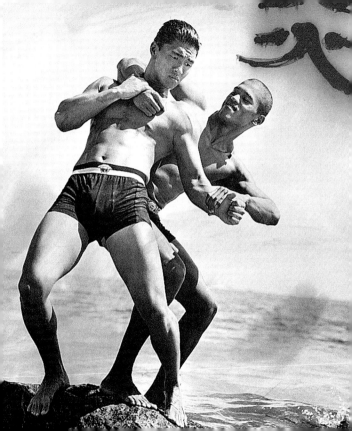

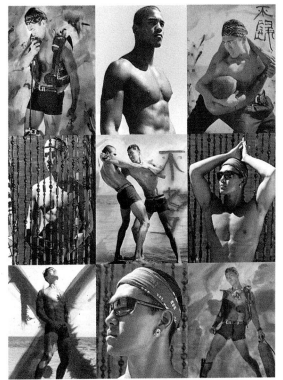

115

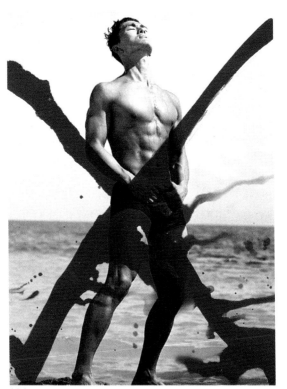

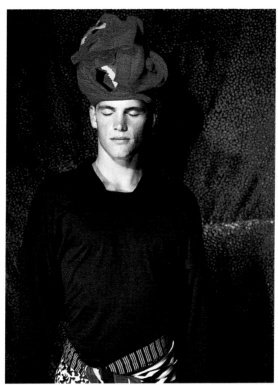

118

121

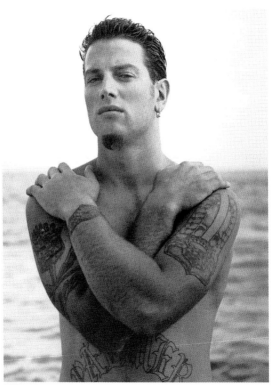

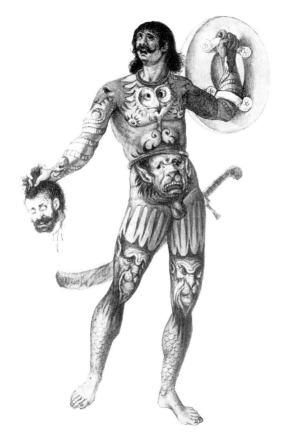

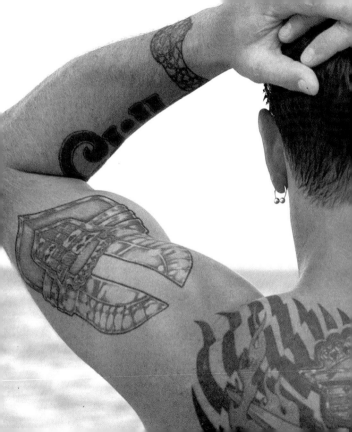

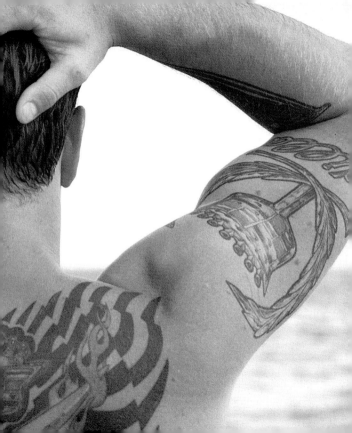

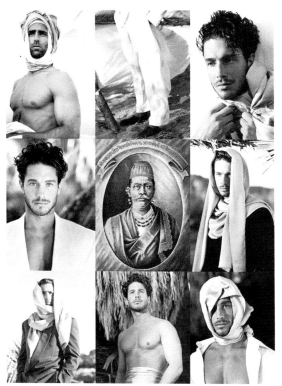

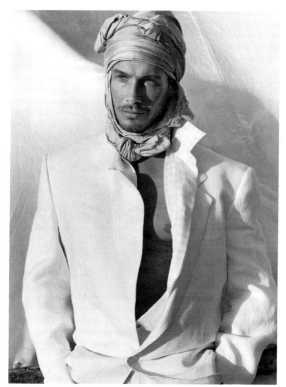

127

*Versace the designer is not afraid to risk
everything to force a vision of the future that
is passionate, colorful, urgent and exciting.
He sees possibilities everywhere.
Gianni my friend does the same.*

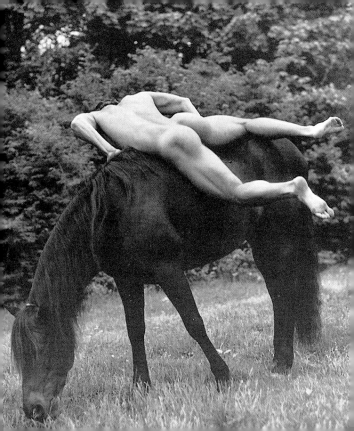

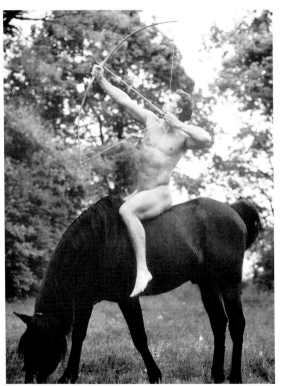

132

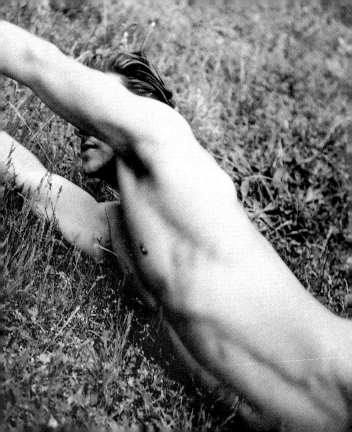

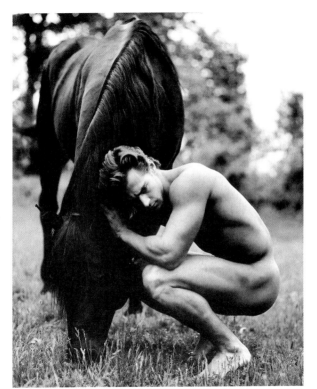

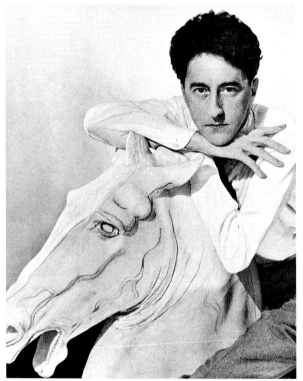

136

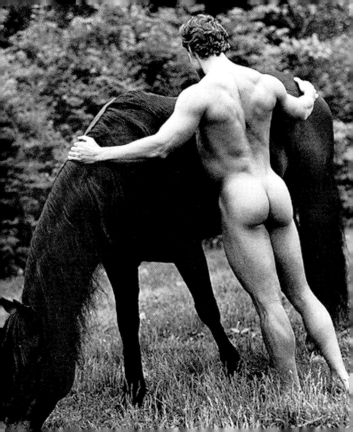

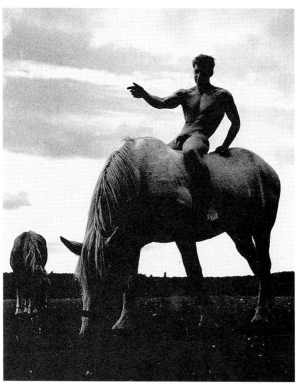

138

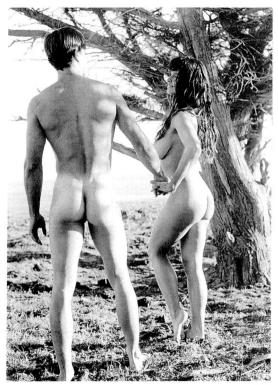

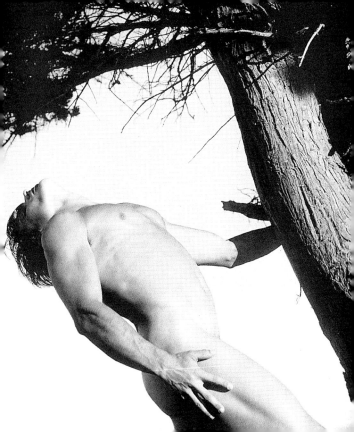

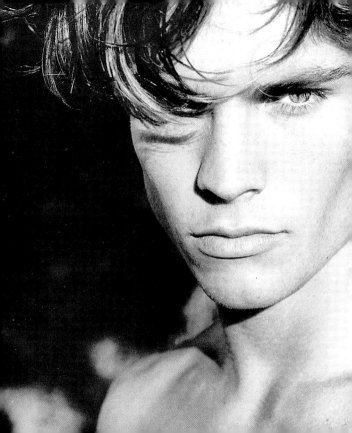

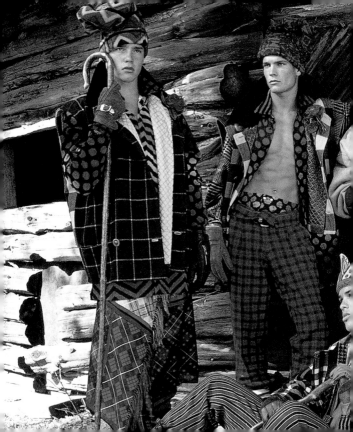

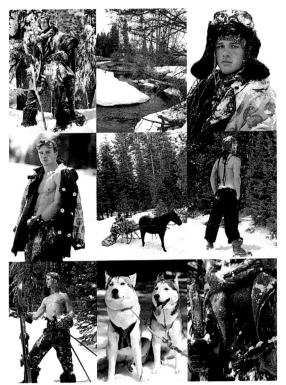

153

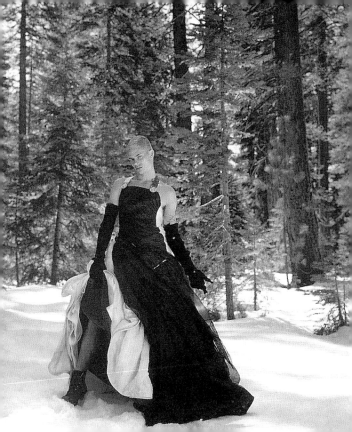

Uncle High Lonesome

Barry Hannah

They were coming toward me—this was 1949—on their horses with their guns, dressed in leather and wool and canvas and with different sporting hats, my father and his brothers, led by my uncle on this his hunting land, several hundred acres called Tanglewood still dense in hardwoods but also opened by many meadows, as a young boy would imagine from cavalry movies. The meadows were thick with fall cornstalks, and the quail and doves were plenty. So were the squirrels in the woods where I had been let off to hunt at a stand with a thermos of chocolate and my 28 double. At nine years old I felt very worthy, for a change, even though I was a bad hunter. But something had gone wrong. My father had put me down in a place they were hunting toward. Their guns were coming my way. Between me and them I knew there were several coveys of quail to ground, frozen in front of the dogs, two setters and a pointer, who were now all stiffening into the point. My uncle came up first. This was Peter Howard, the man I was named for, married but childless at forty-five. I was not much concerned. I'd seen, on another hunt, the black men who stalked for my uncle flatten to the ground during the shooting, it was no big thing. In fact I was excited

155

to be receiving fire, real gunfire, behind my tree. We had played this against Germans and Japanese back home in my neighborhood. But now I would be a veteran. Nobody could touch me at War.

My uncle came up alone on his horse while the others were still hacking through the overhang behind him. He was quite a picture. On a big red horse, he wore a yellow plaid corduroy vest with watch-chain across over a blue broadcloth shirt. On his bald head was a smoky brown fedora. He propped up an engraved sixteen gauge double in his left hand and bridled with his right, caressing the horse with his thighs over polo boots a high gloss tan. An unlit pipe was fixed between his teeth. There was no doubting the man had a sort of savage grace, though I noticed later in the decade remaining to his life that he could also look, with his ears out, a bit common, like a Russian in the gate of the last Cold War mob; thick in the shoulders and stocky with a beligerance like Kruschev. Maybe peasant nobility is what they were, my people. Uncle Peter Howard watched the dogs with a pleasant smile now, with the sun on his face at midmorning. I had a long vision of him. He seemed, there on the horse, patient and generous with his time and his lands, waiting to flush the quail for his brothers. I saw him as a permanent idea, always handy to reverie: the man who could do things. In the face he looked much like—I found out later—the

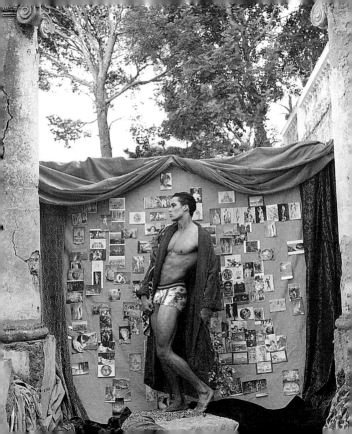

criminal writer Jean Genet, merry and byzantine in the darks of his eyes. Shorter and stockier than the others and bald, like none of them, he loved to gamble. When he was dead I discovered that he was also a killer and not a valiant one. Of all the brothers he was the most successful and the darkest. The distinct rings under my eyes in middle age came directly from him, and God knows, too, my religious acquaintance with whiskey.

The others, together, came up on their horses, ready at the gun. They were a handsome clan. I was happy to see them approach this way, champion enemy cavalry, gun barrels toward me, a vantage not many children in their protected childhoods would be privileged to have. I knew I was watching something rare, seen as God saw it, and I was warm in my ears, almost flushed. My uncle Peter tossed a stick over into a stalk pile and the quail came out with that fearsome helicopter bluttering noise always bigger than you are prepared for. The guns tore the air. You could see sound waves and feathers in a space of dense blue-gray smoke. I'd got behind my big tree. The shot ripped through all the leaves around. This I adored.

Then I stepped out into the clearing, walked toward the horses, and said hello.

My uncle Peter saw me first, and he blanched in reaction to my presence in the shooting zone. He nearly fell from his

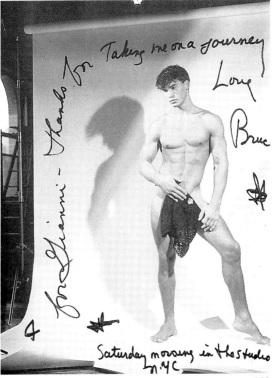

For Gianni – Thanks for Taking me on a journey

Love

Bruce

Saturday morning in the studio
N.Y.C.

159

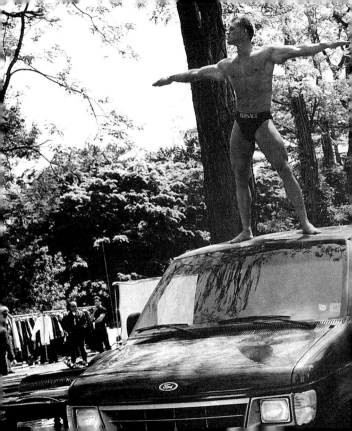

horse, like a man visited by a spirit-ghoul. He waddled over on his glossy boots and knelt in front of me, holding my shoulders.

"Boy? Boy? Where'd you come from? You were *there*?"

"Pete, son?" called my father, climbing down mystified. "Why didn't you call out? You could've, we could've …"

My uncle hugged me to him urgently, but I couldn't see the great concern. The tree I was behind was wide and thick, I was a hunter, not a fool. But my uncle was badly shaken, and he began taking it out on my father. Maybe he was trembling, I guess now, from having almost shot yet another person.

"Couldn't you keep up with where your own boy was?"

"I couldn't know we'd hunt this far. I've seen you lost yourself out here."

An older cousin of mine had had his calf partially blown away in a hunting accident years ago, out squirrel hunting with his brother. Even the hint of danger would bring a tongue-lashing from the mothers. Also, I personally had had a rough time near death, though I hadn't counted up. My brother had nearly cut my head off with a sling blade when I walked up behind as a toddler, but a scar on the chin was all I had. A car had run me down as I crossed the street in first grade. Teaching me to swim the old way, my pa had watched me drown, almost, in the ocean off a pier he'd thrown me from. But this skit I had planned, it was no trouble. I had wanted

163

them to fire my way, and it had been a satisfactory experience, being in the zone of fire.

I felt for my father who was, I suppose, a good enough man. But he was a bumbler, an infant at a number of tasks, even though he was a stellar salesman. He had no grace, though he was nicely dressed and handsome, black hair straight back, with always a good car and a far traveller in it around the United States, Mexico and Canada. His real profession was a lifetime courting in awe of the North American Continent—its people, its birds, animals, and fish. I've never met such an humble pilgrim of his own country as my father, who had the reverence of a Whitman and a Sandburg together without having read either of the gentlemen. But a father's humility did not cut much ice with this son, although I enjoyed all the trips with him and mother.

From that day on my uncle took more regard of me. He took me up, really, as his own, and it annoyed my turkey-throated aunt when I visited, which was often. We lived only an hour and a half away, and my uncle might call me up just to hear a baseball game on the radio with him as he drove his truck around the plantation one afternoon. On this vast place were all his skills and loves, and they all made money: a creosote post factory, turkey and chicken houses, cattle, a Big Dutchman farm machinery dealership; his black help in their gray weathered wrinkled houses; his

lakes full of bass, crappie, bluegills, catfish, ducks and geese, where happy customer/friends from about the county were let fish and sport, in the spirit of constant merry obligation each to each that runs the rural South. Also there was a bevy of kin forever swarming toward the goodies, till you felt almost endlessly redundant in ugly distant cousins. Uncle Peter had a scratchy well-deep voice in which he offered free advice to almost everybody except his wife. And he would demand a hug with it and be on you with those black grinding whiskered cheeks before you could grab the truck door. He was big and clumsy with love, and overall a bit imperial; short like Napoleon, he did a hell of a lot of just … surveying. Stopping the truck and eyeballing what he owned as if it were a new army at rest across the way now, then with just the flick of his hand he'd … turn up the radio for the St. Louis Cardinals, the South's team then because the only broadcast around. I loved his high chesty grunts when one of his favorites would homer. He'd grip the steering wheel and howl in reverential delight: "Musial! Stan the Man!" I was no fan, a baseball dolt, but I got into it with my uncle.

Had I known the whole truth of where he had come from, I would have been even more impressed by his height and width of plenty. I mean not only from the degrading grunting Depression, beneath broke, but before that to what must have

165

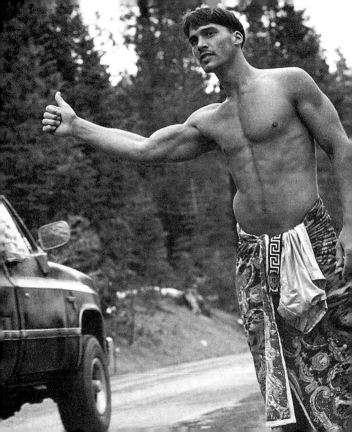

been the most evil hangover there is, in a jail cell with no nightmare but a real murder of a human being in your mind, the marks of the chairlegs he ground in your face all over you, and the crashing truth of your sorriness in gambling and drink so loud in your head they might be practicing the trapdoor for the noose over and over right outside the door. That night. From there. Before the family got to the jurors. Before the circuit judge showed up to agree that the victim was an unknown quantity from *out of town*. Before they convicted the victim of not being from here. Before he himself might have agreed on his own reasonable innocence and smiled into a faint light of the dawn, just a little rent down on any future at all. That was a far trip, and he must have enjoyed it all every time we stopped and he, like Napoleon, surveyed.

He taught me to fish, to hunt, to handle dogs, to feed poultry, to stand watch at the post factory over a grown black man while he left in a truck for two hours. This I highly resented.

"I want to see if this nigger can count. You tell me," he said, right in front of the man, who was stacking posts from the vat with no expression at all. He had heard but he didn't look at me yet, and I was afraid of when he would.

Such were the times that Peter Howard was hardly unusual in his treatment of black help around the farm. He healed their rifts, brought the men cartons of cigarettes. He got

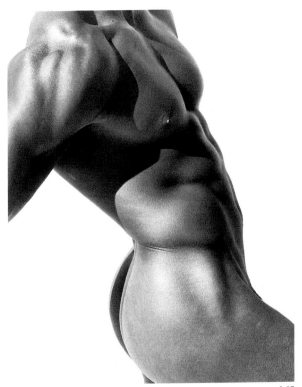

them medical treatment and extended credit even to children who had run away to Chicago. Sometimes he would sock a man in the jaw. I don't believe the current etiquette allowed the man to hit back. In his kitchen his favorite jest, habitual, was to say to a guest in front of their maid Elizabeth: "Lord knows, I do hate a nigger!" This brought huge guffaws from Elizabeth, and Peter was known widely as a hilarious crusty man, good to his toes. But I never thought any of this was a bit funny, and I wanted my uncle to stop including me in this bullying niggerism, maybe go call a big white man a nigger.

While he was gone those two hours in the truck I figured on how mean an act this was to both me and the man stacking the fence poles. I never even looked his way. I was boiling mad and embarassed and could not decide what my uncle *wanted* from this episode. Was he training me to be a leader of men? Was he squeezing this man, some special enemy, the last excruciating turn possible, by use of a mere skinny white boy, but divine by kin, wearing his same name? I couldn't find an answer with a thing decent in it. I began hating Uncle Peter. When he came back I did not answer him when he wanted to tally my figure with the black man's. I said nothing at all. He looked at me in a slightly blurred way, his eyes like glowing knots in a pig's face, I thought. He had on his nice fedora but his face was spreading and reddening,

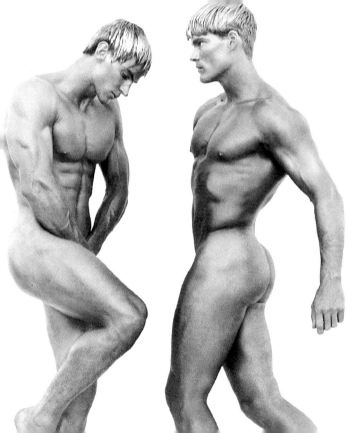

almost like a fiend in a movie. Too, I smelled something in the car as from an emergency room I'd been in when I was hit by that car, waking up to this smell.

"Wharoof? Did you ever answer? Didja gimme the number?"

"Have you been in an accident somewhere, Uncle Peter?"

"No. Let me tell you. I have no problem. I know you might've heard things. This"—he lifted out a pint bottle of vodka, Smirnoff—"is just another one of God's things, you understand? We can use it, or you can abuse it. It is a gift to man in his lonesomeness." To illustrate he lifted it, uncapped it, turned it up, and up came enormous bubbles from the lip as in an old water cooler seriously engaged. He took down more than half of the liquor. The man could drink in cowboy style, quite awesomely. I'd never heard a word about this talent before.

"I'm fessin' up. I'm a bad man. I was using you out here as an alibi for having a drink down the road there, so's your aunt wouldn't know. She has the wrong idea about it. But she knew I wouldn't drink with you along."

"You could drink right here in front of me. I wouldn't tell, anyway."

"Well. I'm glad to know it. It got to my conscience and I came back to make my peace with you about it. Everything between you and me's on the up and up, pardner."

172

"You mean you didn't need me counting those poles at all?"

"Oh yes I did. It was a real job. It wasn't any Roosevelt make-work."

"Don't you consider that man over there has any feelings, what you said right in front of him?"

"What's wrong with shame, boy? Didn't you ever learn by it? You're tender and timid like your pop, you can't help it. But you're all right, too."

"Anybody ever shame you real bad, Uncle Peter?"

He looked over, his jowls even redder and gone all dark and lax, gathered up by his furious eyes. "Maybe," he said. An honest answer would have been, had he come all out: "Once. And I killed him." I wonder how much of that event was in his mind as he looked at me sourly and said "Maybe."

He feared my aunt, I knew it, and let me off at the house, driving off by himself while I gathered my stuff and waited for my folks to pick me up. I heard later that he did not return home for three weeks. For months, even a year, he would not drink, not touch a drop, then he would have a nip and disappear. Uncle Peter was a binge drinker. Still, I blamed my aunt, a fastidious and abrasive country woman with a previous marriage. It was a tragedy she could give him no children and I had to stand in as his line in the family. She blundered here and there, saying wrong and hurtful things, a hag of unnecessary

truth at family gatherings—a comment about somebody's weight, somebody's hair, somebody's lack of backbone. She was always correcting and scolding when I visited, and seemed to think this was the only conversation possible between the old and young, and would have been baffled, I think, had you mentioned it as an unbearable lifetime habit. I blamed her for his drinking and his insensitivity to blacks. He was doing it to show off to evil her, that's what. He was drinking because he could not stand being cruel.

The next time I saw him he had made me two fishing lures, painting them by hand in his shop. These he presented me along with a whole new Shakespeare casting reel and rod. I'd never caught a fish on an artificial lure, and here with the spring nearly on we had us a mission. His lakes were full of big healthy bass. Records were broken every summer, some of them by the grinning wives and children of his customers, so obliged to Mister Peter, Squire of Lake County. On his lands were ponds and creeks brimful and snapping with fish almost foreign they were so remote from the roads and highways. You would ramble and bump down through a far pasture with black angus in it, spy a stretch of water through leaves, and as you came down to it you heard the fish in a wild feeding so loud it could have been school-children out for a swim. I was trembling to go

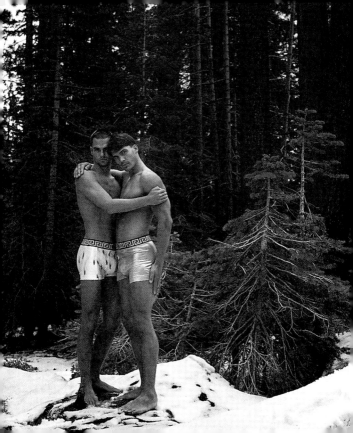

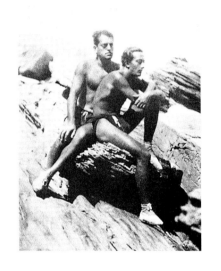

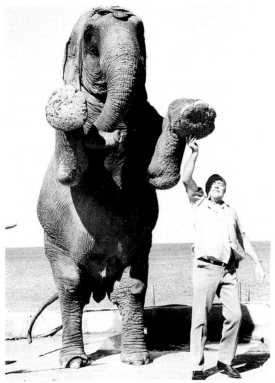

177

out with him to one of these far ponds. It seemed forever before we could set out. Uncle Peter had real business, always, and stayed in motion constantly like a shark who is either moving or dead. Especially when he came out of a bender, paler and thinner, ashen in the face almost like a deacon. He hurled himself into penitential work. His clothes were plainer, like a sharecropper's more than the baron's, and it would be a few weeks before you'd see the watch chain, the fedora or the nice boots—the cultured European scion among his vineyards, almost.

I did not know there were women involved in these benders, but there were. Some hussy in a motel in a bad town. I'd imagine truly deplorable harlots of both races, something so bad it took more than a bottle a day to maintain the illusion you were in the room with your own species. He went the whole deplorable hog and seemed unable to reroute the high lonesomes that came on him in other fashion. But had I known I'd have only cheered for his happiness against my aunt, whom I blamed for every misery in him.

At home my father meant very well, but he didn't know how to do things. He had no grace with utensils, tools or equipment. We went fishing a great many times, never catching a thing after getting up at four and going long distances. I think of us now fishing with the wrong bait, at the wrong depth, at the wrong time. He could make

178

money and drive (too slowly), but the processes of life eluded him. As a golfer he scored decently, but with an ugly dropping swing. He was near childlike with wonder when we traveled, and as to sports, girls, hobbies and adventures my father remained somewhat of a baffled pupil throughout his life and I was left entirely to my own devices. He had no envy of his wealthy brother's skills at all, on the other hand, only admiration. "Old Peter knows the *way* of things, doesn't he, son?" he'd cheer. It seemed perfectly all right that he himself was a dull and slow slob. I see my father and the men of his generation in their pinstripe suits and slicked-back hair, standing beside their new automobiles or another symbol of prosperity that was the occasion for the photograph, and I admire those men for accepting their selves and their limits better, and without therapy. There's more peace in their looks, a more possessed handsomeness, even with the World War around them. You got what you saw more, I'd guess, and there was plainer language then, there had to be. My father loved his brother and truly pitied him for having no son of his own. So he lent me to him often.

Mark my father in the dullish-but-worthy ledger as no problem with temper, moodiness or whiskey, a good man of no unpleasant surprises that way. He was sixty-five years old before he caught a bass on a spinning reel with artificial

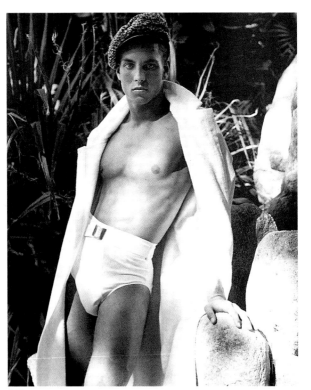

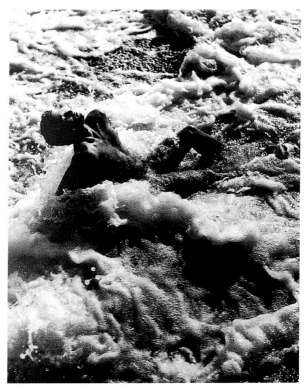

181

bait. He died before he had the first idea how to work the remote control for the television.

At last Uncle Peter had the time to take me and himself out to a far pond, with a boat in the bed of the truck and his radio dialed to his beloved Cardinals. We drove so far the flora changed and the woods were darker, full of odd lonesome longlegged fowl like sea birds. The temperature dropped several degrees. It was much shadier back here where nobody went. Uncle Peter told me he'd seen a snapping turtle the width of a washtub out in this pond. It was a strange, ripe place, fed by springs, the water nearly as clear as in Florida lakes.

He paddled while I threw a number of times and, in my fury to have one on, messed up again and again with a backlash, a miscast, and a wrap, my lure around a limb six feet over the water next to a water mocassin who raised its head and looked at me with low interest. I jerked the line, it snapped, and the handpainted lure of all Uncle Peter's effort was marooned in the wood. I was a wretched fool, shaking with a rush of bile.

"Take your time, little Pete. Easy does it, get a rhythm for yourself."

I tied the other lure on. It was a bowed lure that wobbled crazily on top of the water. I didn't think it had a prayer and was still angry about losing the good one, which looked

182

exactly like a minnow. We were near the middle of the pond, but the middle was covered with dead tree stumps and the water was clear a good ways down.

A big bass hit the plug right after it touched the water on my second cast. It never gave the plug a chance to be inept. It was the first fish I'd ever hooked on artificial bait, and it was huge. It moved the boat. My arms were yanked forward, then my shoulders, as the thing wanted to tear the pole out of my palms on the way to the pond bottom. I held up and felt suddenly a dead awful weight and no movement. The bass had got off and left me hooked on a log down there, I knew. What a grand fish. I felt just dreadful until the thrashing had cleared and I looked down into the water.

The fish was still on the plug in ten feet of water. He was smart to try to wrap the line around the submerged log, but he was still hooked himself, and was just sitting there breathing from the gills like some big thing in an aquarium. My uncle was kneeling over the gunwale looking at the fish on the end of the line. His fedora fell in the water. He plucked it out and looked up at me in sympathy. I recall the situation drew a tender look from him such as I'd never quite seen.

"Too bad, little Pete. There she is, and there she'll stay. It's almost torture to be able to look at your big fish like that, ain't it? Doesn't seem fair."

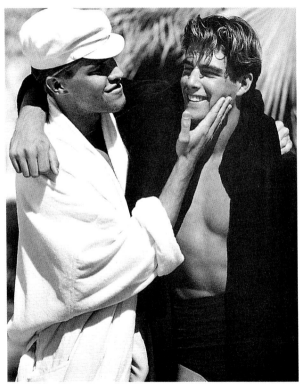

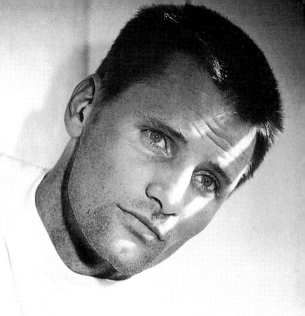

The important thing is to go.

GIANNI VERSACE

Uncle Peter didn't seem to enjoy looking in the water. Something was wrong, besides this odd predicament.

"No. I'm going down for it. I'm going to get the fish."

"Why boy, you can't do that."

"Just you watch. That fish is mine."

I took off all my clothes and was in such a hurry I felt embarrassed only at the last. I was small and thin and ashamed in front of Uncle Peter, but he had something like fear or awe on his face I didn't understand.

"That fish big as you are," he said in a foreign way. "That water deep and snakey."

But I did swim down, pluck up the fish by its jaws, and come back to throw it in the boat. The plug stayed down there, visible, very yellow, as a monument to my great boyhood enterprise, and I wonder what it looks like now, forty years later.

My uncle had the fish mounted for me. It stayed in our home until I began feeling sorry for it after Peter's death, and I gave it to a barber for his shop. The fish weighed about nine pounds, the biggest I'll ever catch.

I was not the same person to my uncle after that afternoon. I did not quite understand his regard of me until my father explained something very strange. Uncle Peter was much the country squire and master of many trades, but he could not swim and he had a deathly fear of deep water. He had wanted

to join the navy, mainly for its white officers' suits, but they had got him near a deep harbor somewhere in Texas and he'd gone near psychotic. He seemed to expect great creatures to get out of the sea and come for him, too, and it was past reason, just one of those odd strands in the blood about which there can be no comment or change. Since then I've talked to several country people with the same fear, one of them an All-American linebacker. They don't know where it came from and don't much want to discuss it.

When television appeared I was much enamored of Howdy Doody. Some boys around the neighborhood and I began molding puppet heads from casts you could buy at the five and dime. You could have the heads of all the characters from the Howdy show in plaster of Paris. Then you'd put a skirt with arms on it and commence the shows on stage. We wrote whole plays, very violent and full of weapons and traps, all in the spirit of nuclear disaster and Revelations, with Howdy, Flubadub and Clarabelle. I couldn't believe my uncle's interest in the puppets when I brought them over and set up the show in his workshop.

The puppets seemed to worry him like a bouncing string would worry a cat. He looked at me as if I were magic, operating these little people and speaking for them. He had the stare of an intense confused infant. When I'd raise

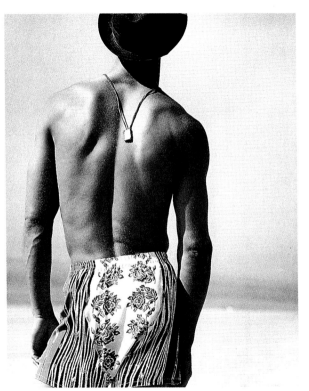

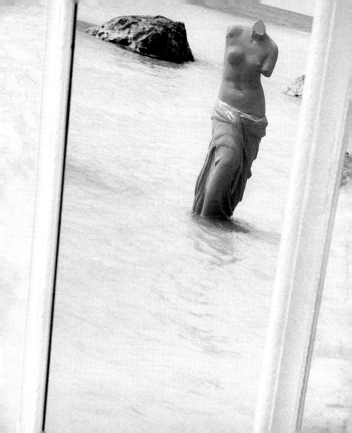

my eyes to him, he'd look a bit ashamed, as if he'd been seduced into thinking these toys were living creatures. He watched my mouth when I spoke in a falsetto for them.

I still don't know what the hell went on with him and the puppets, the way he watched them, then me. You'd have thought he was staring into a world he never even considered possible, somewhere on another planet; something he'd missed out on and was very anxious about. I noticed, too, that he would dress *up* a little for the puppet shows. Once he wore his fedora and a red necktie as well.

A number of years went by when I did not see my uncle much at all. These were my teen years when I was altogether a different person. He remained the same, and his ways killed him. I don't know if the dead man in his past urged him toward the final DTs and heart attack, nor will I ever know how much this crime dictated his life, but he seemed to be attempting to destroy himself in episode after episode when, as he would only say afterward, the high lonesomes struck him.

The last curious scene when I recall him whole was the summer right after I turned thirteen. We were all around the beach of Bay St. Louis, Mississippi, where we'd gathered for a six-family reunion of my father's people. The Gulf here was brown, fed by the Wolf and Jordan rivers. It provided groaning tables of oysters, shrimp, flounders,

190

crabs and mullet. Even the poor ate very well down here, where there were Catholics, easy liquor and gambling, bingo, Cajuns, Sicilians and Slavs. By far it was the prettiest and most exotic of the towns where any of the families lived, and my Uncle Max and Aunt Ginny were very proud showing us around their great comfortable home, with a screened porch running around three sides where all the children slept for the cool breeze from the bay. All over the house were long troughs of ice holding giant watermelons and cantaloupes and great strawberries. Something was cooking all the time. This was close to heaven, and everybody knew it. You drifted off to sleep with the tales of the aunts and uncles in your ears. What bliss.

Most of us were on the beach or in the water when Uncle Peter went more bizarre, although for this I do have an interpretation that might be right. He had been watching me too intently, to the exclusion of others. He was too *around*, I could feel his eyes close while I was in the water swimming. He was enduring a sea change here at the sea, which he was supposed to be deathly afraid of. I believe he was turning more *urban*, or more cosmopolitan. He'd been to a Big Dutchman convention in Chicago. Somebody had convinced him to quit cigarettes, take up thin cigars, get a massage, and wear an Italian hat, a borsalino hat, which he now wore with sunglasses and an actual designed beach

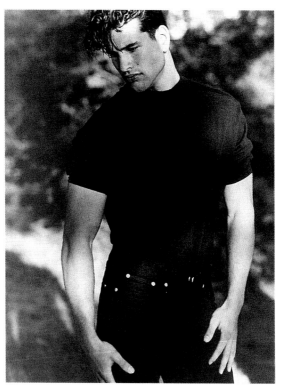

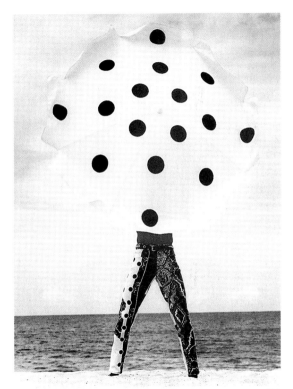

towel, he and his wife sitting there in blue canvas director's chairs. He had been dry for over a year, had lost weight, and now looked somewhat like Versace, the Italian designer. If this was our state's most European town, then by God Uncle Peter would show the way, leading the charge with his Italian hat high and his beach towel waving.

He was telling all of them how he was getting rid of the bags under his eyes. He was going to take up tennis. He had bought a Jaguar sedan, hunter green. Now on the beach as he sat with the other uncles of my father, watching us kids swim, he seemed all prepared for a breakout into a new world, even if he couldn't swim, even in his pale country skin. Here he was in wild denial of his fear of the water. His wife, my aunt, seemed happier sitting there beside him. She'd been kinder lately, and I forgave her much. Maybe they had settled something at home.

I'll remember him there before the next moment, loved and honored and looking ahead to a breakout, on that little beach. He could be taken for a real man of the world, interested even in puppets, even in fine fabrics. You could see him—couldn't you?—reaching out to pet the world. Too long had he denied his force to the cosmos at large. Have me, have me, kindred, he might be calling. May my story be of use. I am meeting the ocean on its own terms. I am ready.

The New Orleans children were a foul-mouthed group in

general out there in the brown water of the bay. Their parents brought them over to vacation and many of the homes on the beach were owned by New Orleans natives. The kids were precocious and street-mouthed, sounding like Brooklynites really, right out of a juvenile delinquent movie. They had utter contempt for the local crackers. The girls used rubes like me and my cousins to sharpen up their tongues on. And they could astound and wither you if you let them get to you. They had that sort of mist of Catholic voodoo around them, too, that you didn't know what to do with.

Some sunbrowned girl, maybe twelve, in a two-piece swimsuit, got nudged around while we were playing, and started screaming at me.

"Hey cracker, eat me!"

"What?"

"Knockin' me with ya foot! Climb on this!" She gave me the finger.

You see? Already deep into sin, weathered like a slut at a canasta table, from a neighborhood that smelled like whiskey on a hot bus exhaust pipe. I guess Uncle Peter saw the distress in my face, although I was probably a year older than the girl. He had heard her too. He began raving at her across the sand and water, waving both arms. He was beside himself, shouting at her to "Never say those things! Never ever say those things to him!"

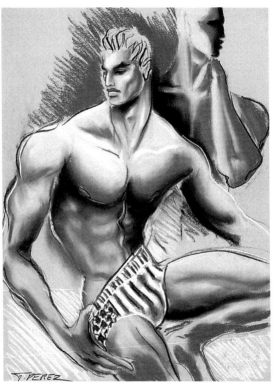

G. PEREZ

196

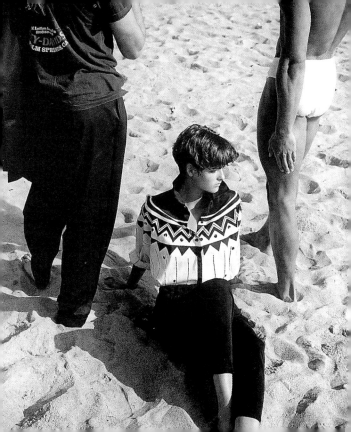

I looked at her, and here was another complicating thing. She had breasts and a cross dangling by a chain between them and was good-looking. Uncle Peter had come up to the waterline and was looking at her too, forcing his hooked finger down for emphasis, "Don't ever!" But her body, leaned back to mock this old man, confused him and broke his effect.

Another uncle called out for him to come back, I was old enough to take care of myself, there wasn't any real problem here. But Uncle Peter hurled around and said: "There *is* a problem. There *is*."

Then he left the beach by himself and we didn't see him for the rest of the reunion. I saw my aunt sitting in their bedroom with her shoulders to me, her head forward, alone, and I understood there was huge tragedy in my uncle, regardless of anything she ever did.

A couple of the brothers went out on his trail. They said he began in a saloon near the seawall in Waveland.

Could it be simply that my Uncle saw, in his nervous rage and unnatural mood, that girl calling me down the road to sin, and he exploded? That he saw my fate coming to me in my teens, as his had, when he killed the man? Or was he needing a drink so badly that none of this matters? I don't know. After that bender he didn't much follow up on any great concern for me. Maybe he gave up on himself.

It took seven years more. My father came and got me at my apartment in the college town and told me about his death, in a hospital over in that county. My father had white hair by then, and I remember watching his head bowed over, his arm over the shoulders of his, their mother, my grandmother, with her own white-haired head bowed in grief no mother should bear. My grandmother repeated over and over the true fact that Peter was always "doing things, always his projects, always moving places." His hands were busy, his feet were swift, his wife was bountifully well-off, forever.

A man back in the twenties came to town and started a poker game. Men gathered and drank. Peter lost his money and started a fight. The man took a chair and repeatedly ground it into his face while Peter was on the floor. Peter went out into the town, found a pistol, came back and shot the man. The brothers went about influencing the jury, noting that the victim was trash, an out-of-towner. The judge agreed. The victim was sentenced to remain dead. Peter was let go.

I've talked to my nephew about this. For years now I have dreamed I killed somebody. The body has been hidden, but certain people know I am guilty, and they show up and I know, deep within, what they are wanting, what this is all about. My nephew was nodding the whole time I was telling him this. He has dreamed this very thing, for years.

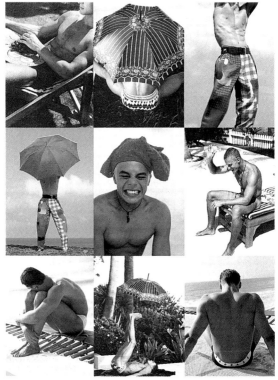

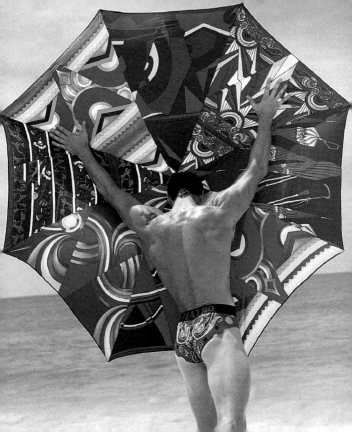

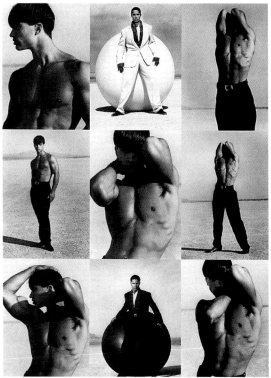

202

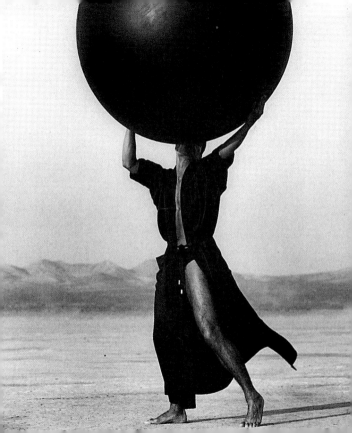

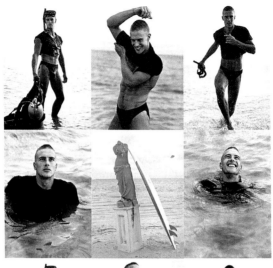
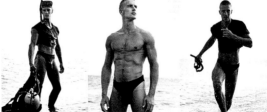

204

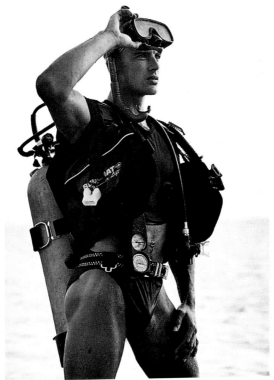

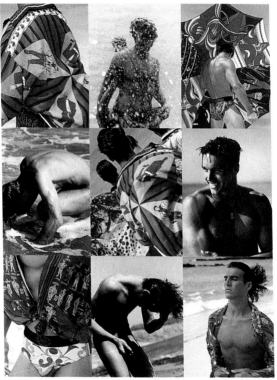

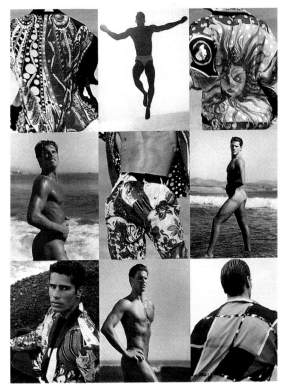

207

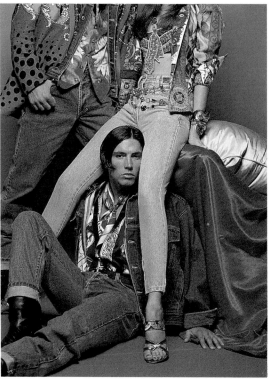

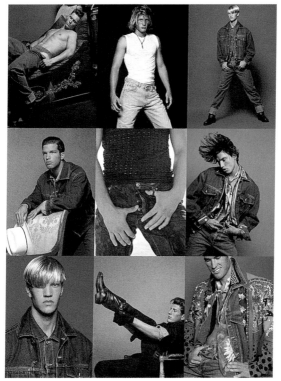

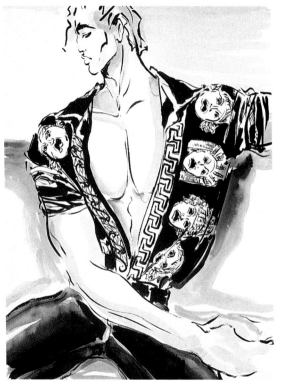

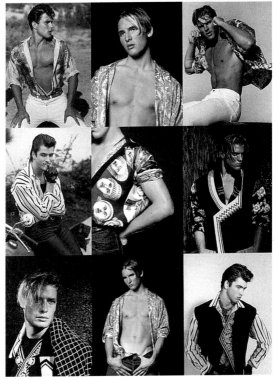

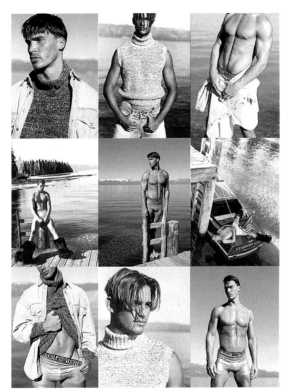

213

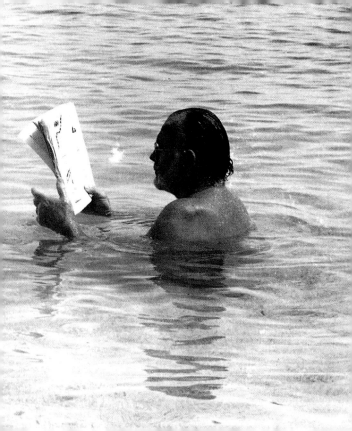

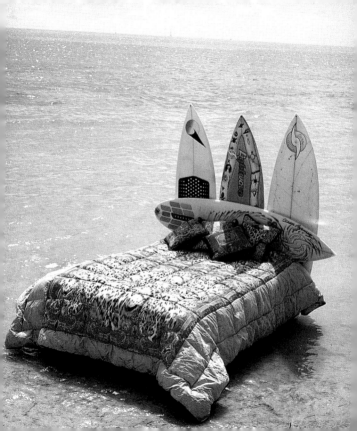

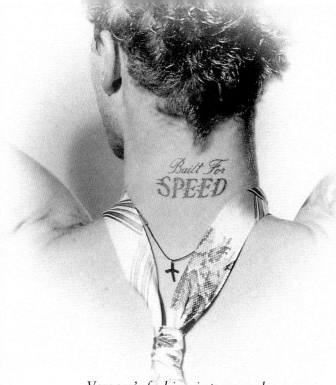

Versace's fashion is pure rock.

ERIC CLAPTON

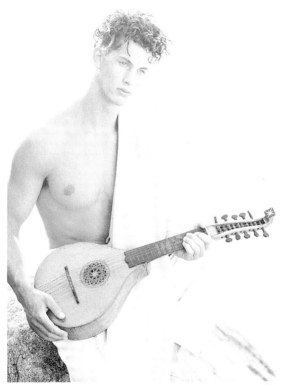

217

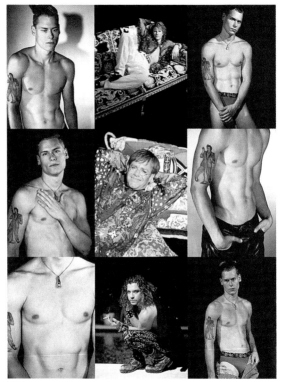

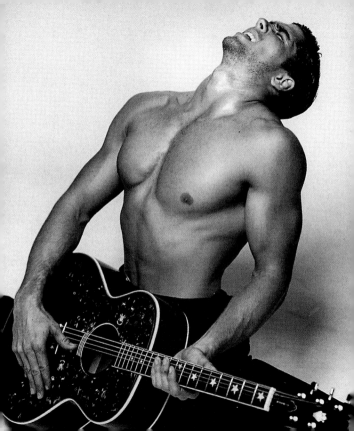

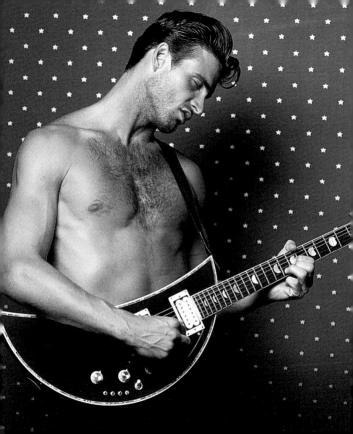

T.PEREZ

221

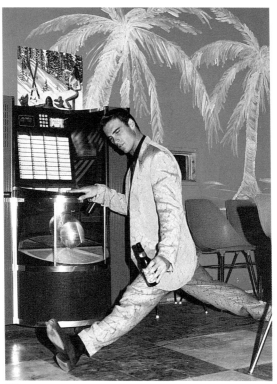

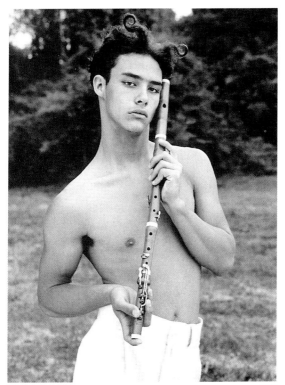

223

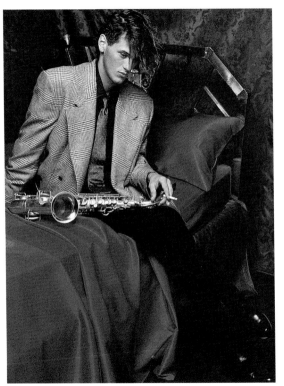

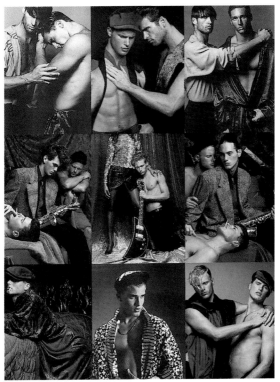

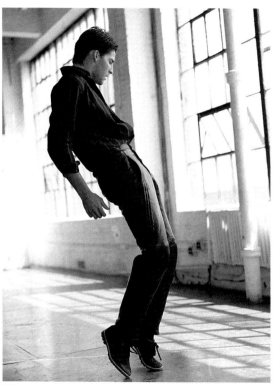

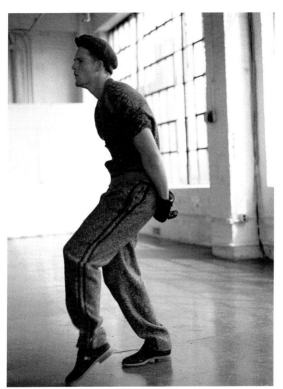

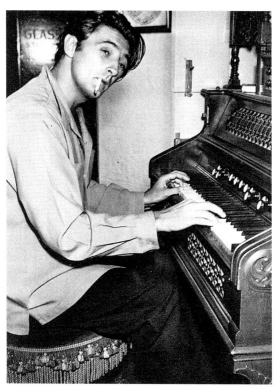

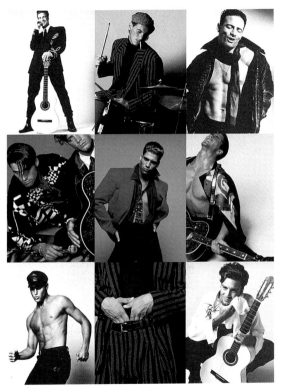

229

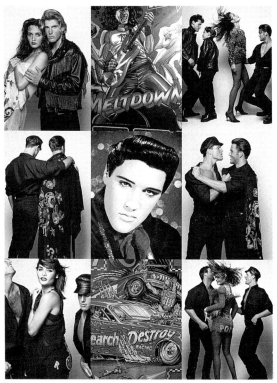

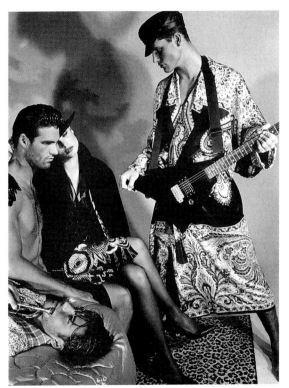

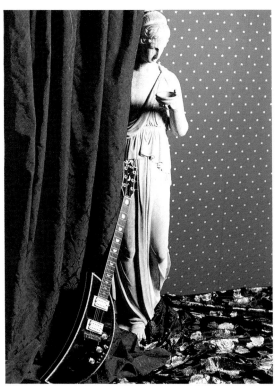

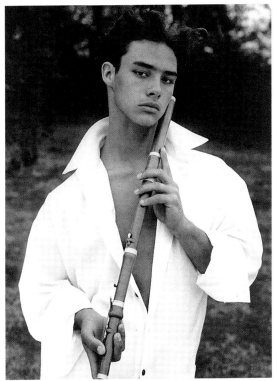

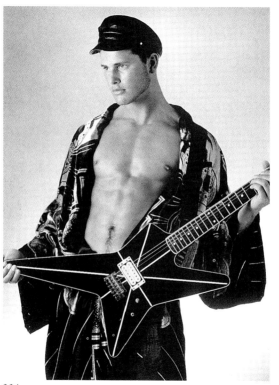

234

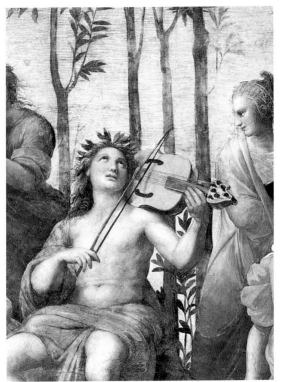

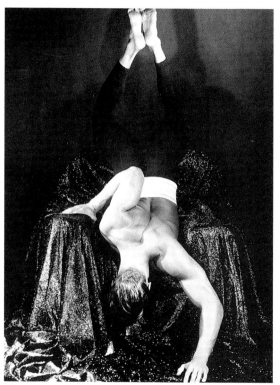

236

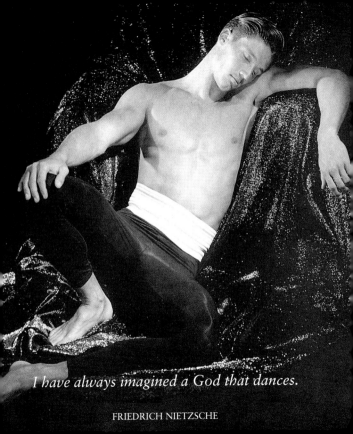

I have always imagined a God that dances.

FRIEDRICH NIETZSCHE

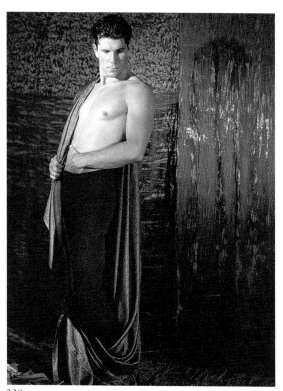

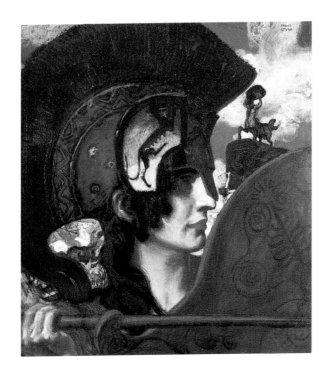

241

242

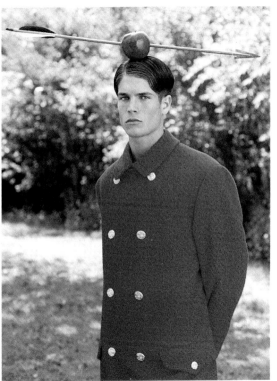

243

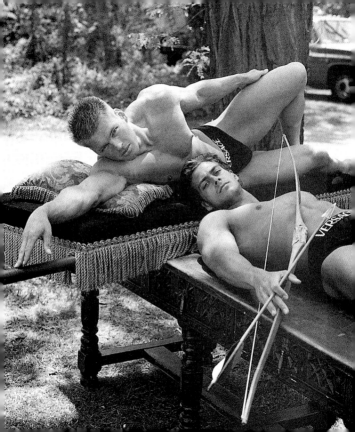

T. PEREZ

248

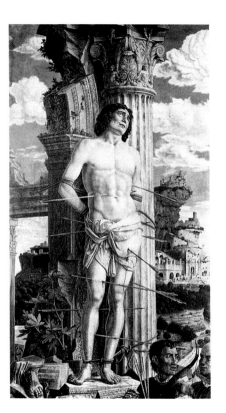

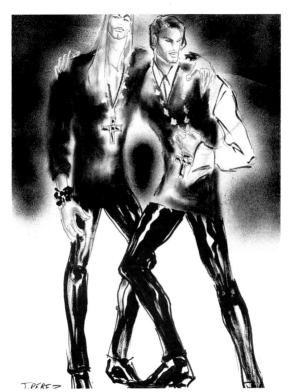

T.PEREZ

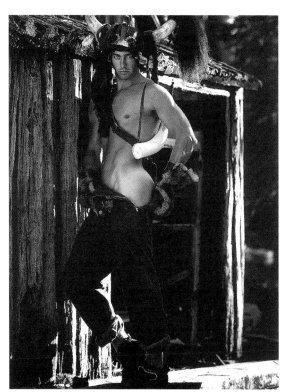

252

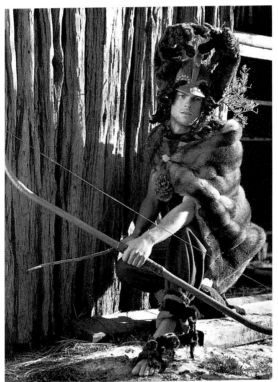

253

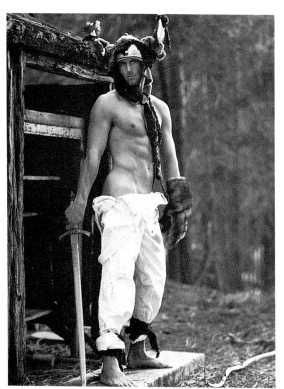

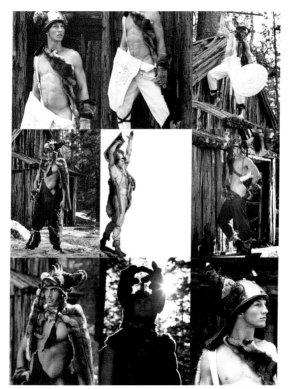

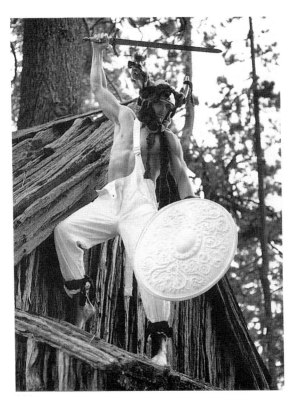

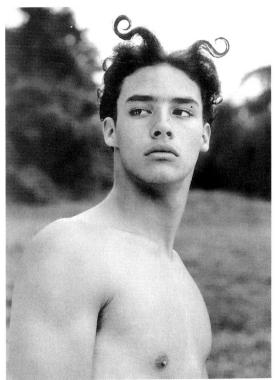

257

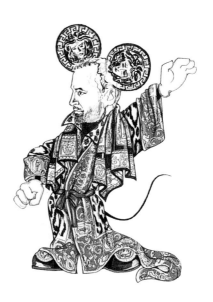

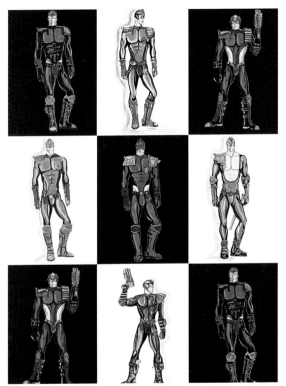

259

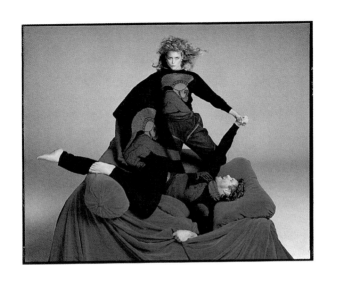

I love men who have the courage
to become "heroes."

GIANNI VERSACE

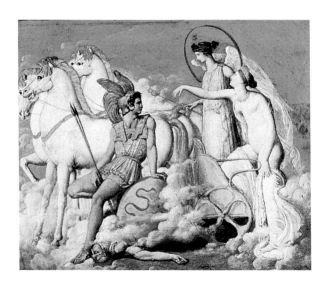

262

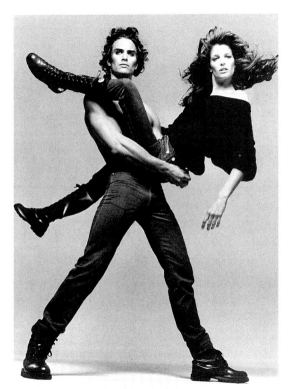

263

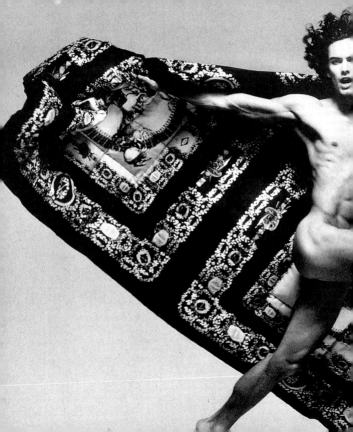

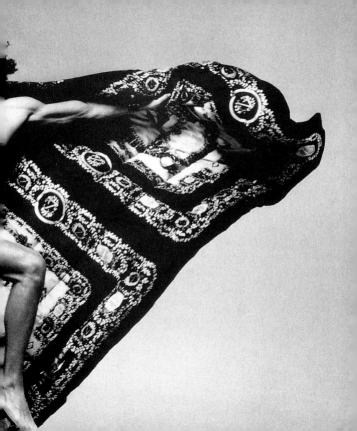

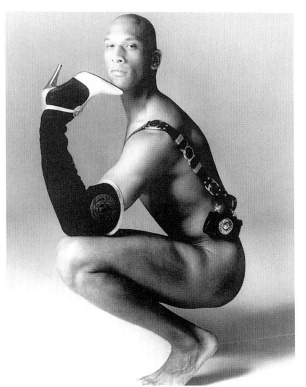

266

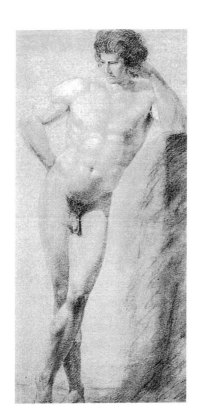

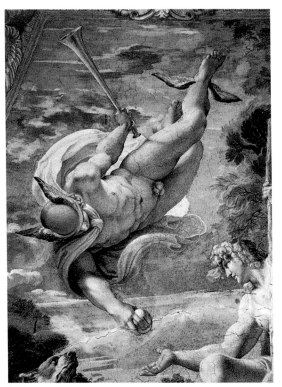

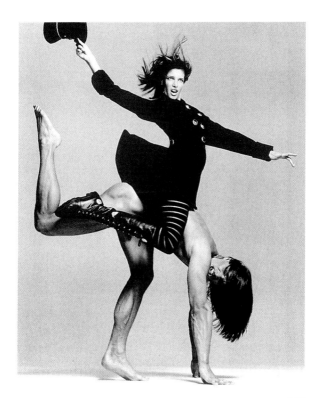

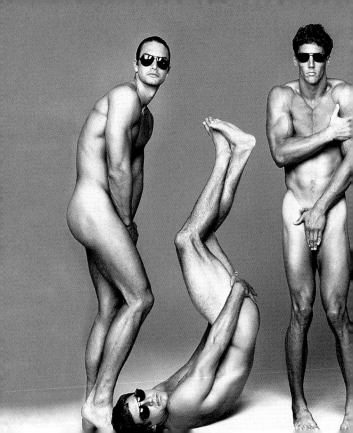

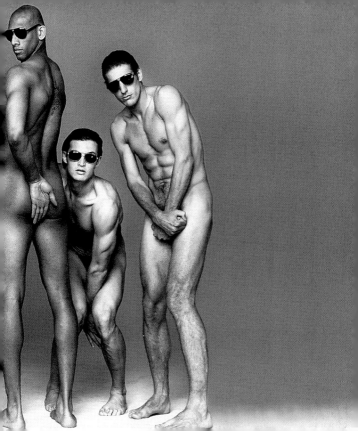

272

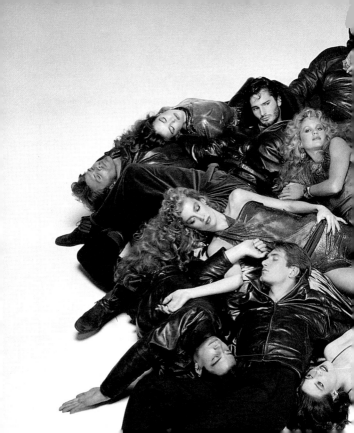

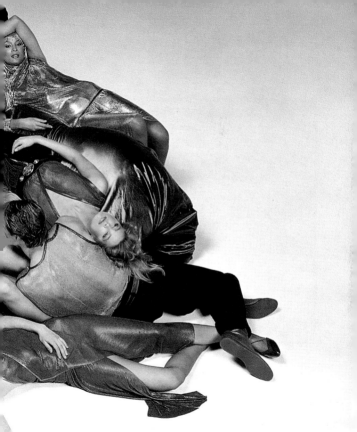

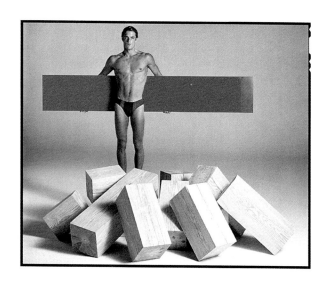

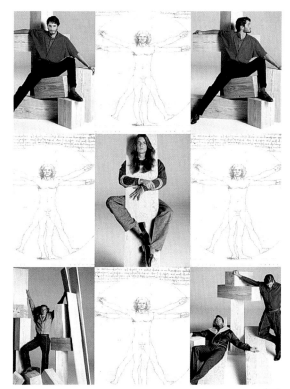

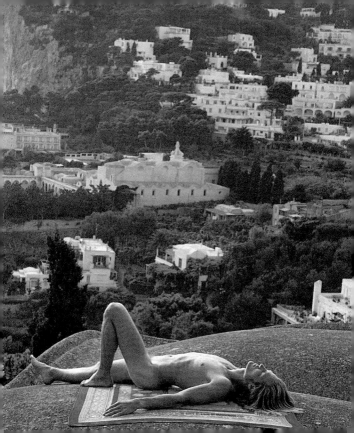

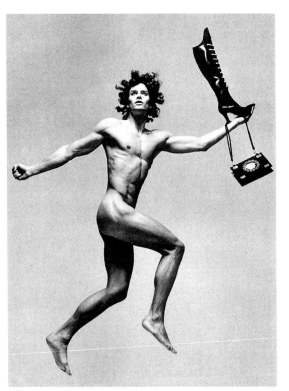

280

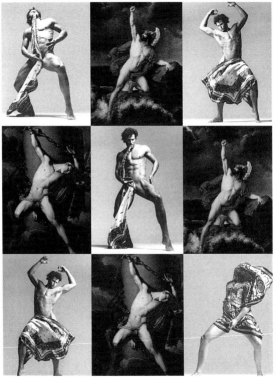

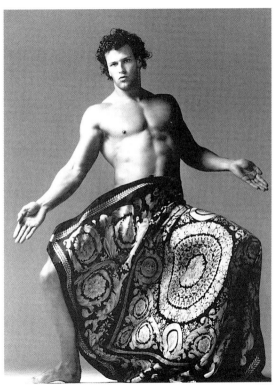

283

Ties ... I hate places where you need one just to get in the door.

GIANNI VERSACE

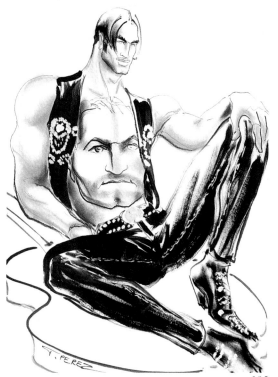

T. PEREZ

285

Art direction
Paul Beck
Donatella Versace Beck

Drawings
Thierry Perez
Bruno Gianesi
Manuela Brambatti

Graphics
Luisa Raponi
Enrico Genevois

Picture research
Tatiana Mattioni

Archive
Stefania Di Gilio

Coordinator
Patrizia Cucco

Publishing consultant
Rollene W. Saal

We would particularly like to thank
everyone who has contributed
to the Gianni Versace collections
over the years.

Leonardo Periodici

Editorial coordinator
Giuseppe Lamastra

Promotion and press
Gabriella Piomboni

Technical consultant
Gianni Gardel

On front cover: photo by Richard
Avedon, 1993
On back cover: portrait
by Karl Lagerfeld

ISBN 0-7892-0382-0
© 1994 Leonardo Arte srl, Milan
© 1997 Abbeville Press, New York
© 1997 Leonardo Periodici srl, Milan

First U.S. edition
10 9 8 7 6 5 4 3 2 1

Library of Congress Cataloging-in-Publication Data

Men without ties / Barry Hannah [et al.].

p. cm.

"A Tiny folio."

ISBN 0-7892-0382-0

1. Men's clothing. 2. Costume design. 3. Versace, Gianni.

I. Hannah, Barry.

TT617.M428 1997

746.9' 2—dc21 97-11520

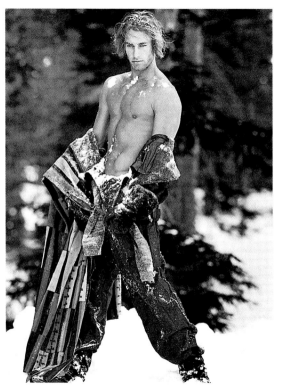

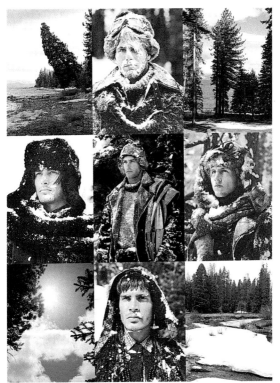

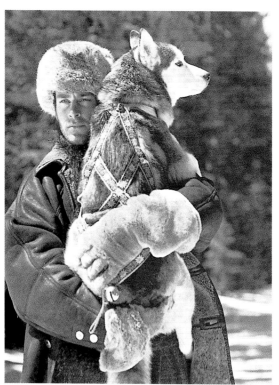

152